APERTURE

PHOTOGRAPHS

BY KEN BOTTO, JACK CARNELL, HELEN CHADWICK, CATHERINE CHALMERS,
GREGORY CREWDSON, BRUCE DAVIDSON, TED DEGENER, WILLIAM EGGLESTON,
ELLIOT ERWITT, ROBERT FLYNT, PAUL FUSCO, BRUNA GINAMMI, NAN GOLDIN,
JILL GRAHAM, PHILIP JONES GRIFFITHS, JAN GROOVER, HORST P. HORST,
JAMES KLOSTY, NICK KNIGHT, MICHIKO KON,
BARBARA KRUGER, DAVID MCDERMOTT & PETER MCGOUGH, ANN MANDELBAUM,
SALLY MANN, ROBERT MAPPLETHORPE, JEFF MERMELSTEIN, PATRICK NAGATANI & ANDRÉE TRACEY,
MARTIN PARR, JEAN PIGOZZI, SYLVIA PLACHY, MIGUEL RIO BRANCO,
NICOLA SCHWARTZ, ANDRES SERRANO, CINDY SHERMAN, LAURIE SIMMONS, SANDY SKOGLUND,
MICHAEL SPANO, NICK WAPLINGTON, ANDY WARHOL, CARRIE MAE WEEMS,
WILLIAM WEGMAN, GARRY WINOGRAND, JOEL-PETER WITKIN

"The Universe is nothing without the things that live in it, and everything that lives, eats" wrote Jean-Anthelme Brillat-Savarin in the preamble to his 1825 *Physiology of Taste, or Meditations on Transcendental Gastronomy.* Brillat-Savarin suggested that the forgotten tenth Muse was Gasterea, who presided over all the pleasures of taste. The feast of superb imagery related to both eating and the edible certainly attests to the possibility of such inspiration. And so inspired, for the first time *Aperture* serves up food . . . for thought.

Even the most superficial study of the cameo role food has played in the history of all the arts would show our extraordinary, endless obsession with food: this fundamental corporeal need has been aestheticized, mythologized, poeticized, and made mystical and symbolic to the point that it represents the body itself. The fascination with food is long in the tooth, and has been manifested over the years in the work of some extremely venerable artists. Many of the photographs seen here either echo or are informed by work—current or historical—from all media.

From the Bacchanalian portrait by Cindy Sherman, to the suggestion of forbidden fruit in Robert Flynt's sensual cherry-clad embrace; from the meals of William Eggleston to those of Sally Mann, to the many other depictions offered, we are reminded of Arcimboldo's portraits, Manet's picnic of picnics the *Déjeuner sur l'herbe,* Daniel Spoerri's "snared" repast, *Kichka's Breakfast,* and more. In a strange, Proustian moment, the meal has become a memory before it is ever tasted. And what we bring to the table is an entire history of eating and tasting that, for better or for worse, describes our culture and identity (note Carrie Mae Weems's *Black Man with a Watermelon*). At the same time, interrogating flavor and the cultural mores of eating and taste, Barbara Kruger asserts "Your flavor is in your mouth." (Perhaps you are what you eat?)

The long-standing traditions of food-related tableaux and still-lifes (Chardin, Cézanne, Thiebaud, to name just a few) are here: from the elegant portraits by Robert Mapplethorpe, to the baroque presentations of Michiko Kon and Joel-Peter Witkin, to the more ethereal work of artists such as Horst and Jan Groover, to the resolutely quotidian stitched photographs by Andy Warhol, this tradition is revealed as anything but inanimate. At

the same time, some of the more gluttonous photographs of taste-testing, devouring, and gastronomic pleasures represented here—be they food-chain-oriented or otherwise—recall those cinematic and literary images stored in our mind's eye—from Peter Greenaway's cannibalistic *The Cook, The Thief, His Wife & Her Lover,* to the magical recipes of Laura Esquivel's *Like Water for Chocolate.* Other invocations of the spirit in the flesh include Helen Chadwick's luminous meat, and Andres Serrano's play on the Last Supper, entitled *Black Supper.*

Speaking of that iconic party of thirteen, the photographs here are accompanied by thirteen lively and personal discussions with some of the most celebrated cooks and chefs working today. Our guests are (in order of appearance): Marcella and Victor Hazan, Bobby Flay, Nobu Matsuhisa, Rose Levy Beranbaum, Sylvia Weinstock, Julia Child, Copeland Marks, Jeremiah Tower, Daniel Boulud, Ismail Merchant, Wolfgang Puck, Nancy Silverton and Mark Peel, and Rick Bayless. Many of these individuals have devoted much of their lives to the discovery and appreciation of food, focusing on everything from the possibilities embodied in a single ingredient, to the interaction of carefully selected and balanced flavors, to the subtleties and intricacies of various cuisines. Who better to speak passionately, sensually, and viscerally about food? Interviewed for *Aperture* by Elizabeth H. Berger, herself an excellent cook, member of *Aperture's* Editorial Advisory Board, and part of the team that conceived *Everything That Lives, Eats,* these creative and accomplished cooks agreed to let their words stand next to images of food which, for the most part, represent nothing that would ever come out of their kitchens. We are grateful to them for their adventurous spirit in collaborating with us. Along with these impassioned dialogues is a modern allegory by writer Frederick Kaufman (another member of the team that chewed on the idea of a food theme) tracing the evolution of Gasterea.

Gastronomy, wrote Brillat-Savarin in M. F. K. Fisher's excellent translation, "rules over our whole life; for the cries of the newborn babe beg for his wet nurse's breast; and the dying man still receives with some pleasure his final potion. . . ." Fresh off the presses and rich with flavor, *Everything That Lives, Eats* presents food, from life to death, and celebrates its myriad manifestations through that ultimate preservative: photography.

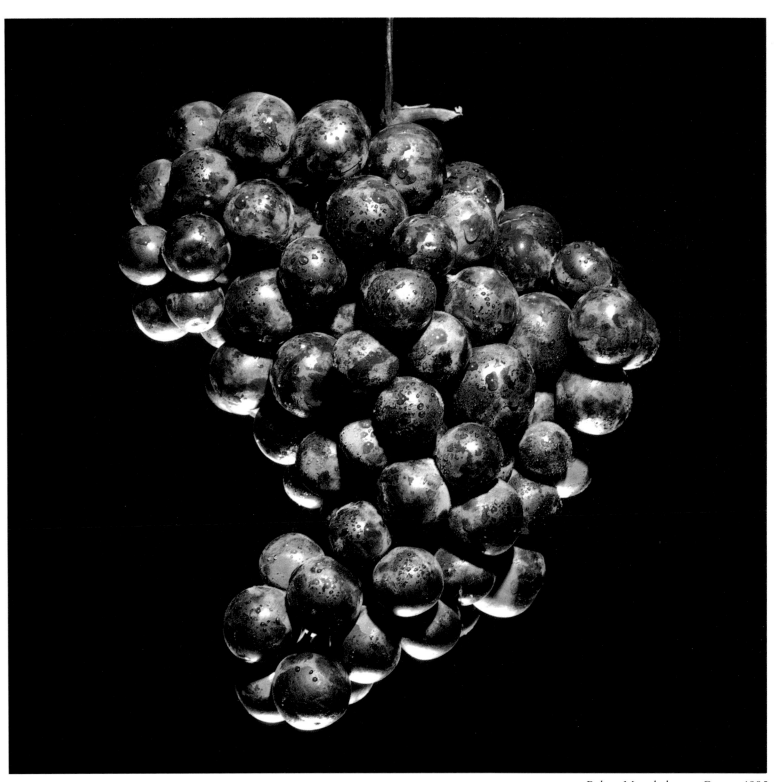

Robert Mapplethorpe, *Grapes*, 1985

SINGLE FISH SINGLE FISH SINGLE FISH

SINGLE FISH

EGG-PLANT SINGLE FISH SIGHT.

A SWEET WIN AND NOT LESS NOISY

THAN SADDLE AND

MORE PLOUGHING AND NEARLY

WELL PAINTED BY LITTLE THINGS SO.

PLEASE SHADE IT A PLAY. IT IS NECESSARY

AND BESIDE THE LARGE SORT IS PUFF.

EVERY WAY OAKLY, PLEASE PRUNE IT NEAR.

IT IS SO FOUND.

IT IS NOT THE SAME.

—GERTRUDE STEIN, FROM *TENDER BUTTONS*

Robert Mapplethorpe, *Fish*, 1985

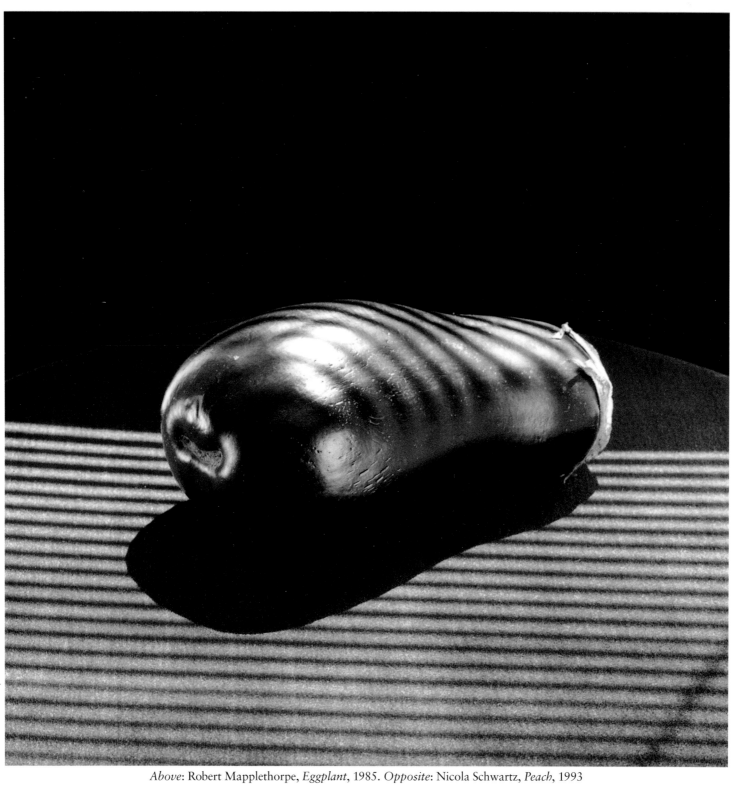

Above: Robert Mapplethorpe, *Eggplant*, 1985. *Opposite*: Nicola Schwartz, *Peach*, 1993

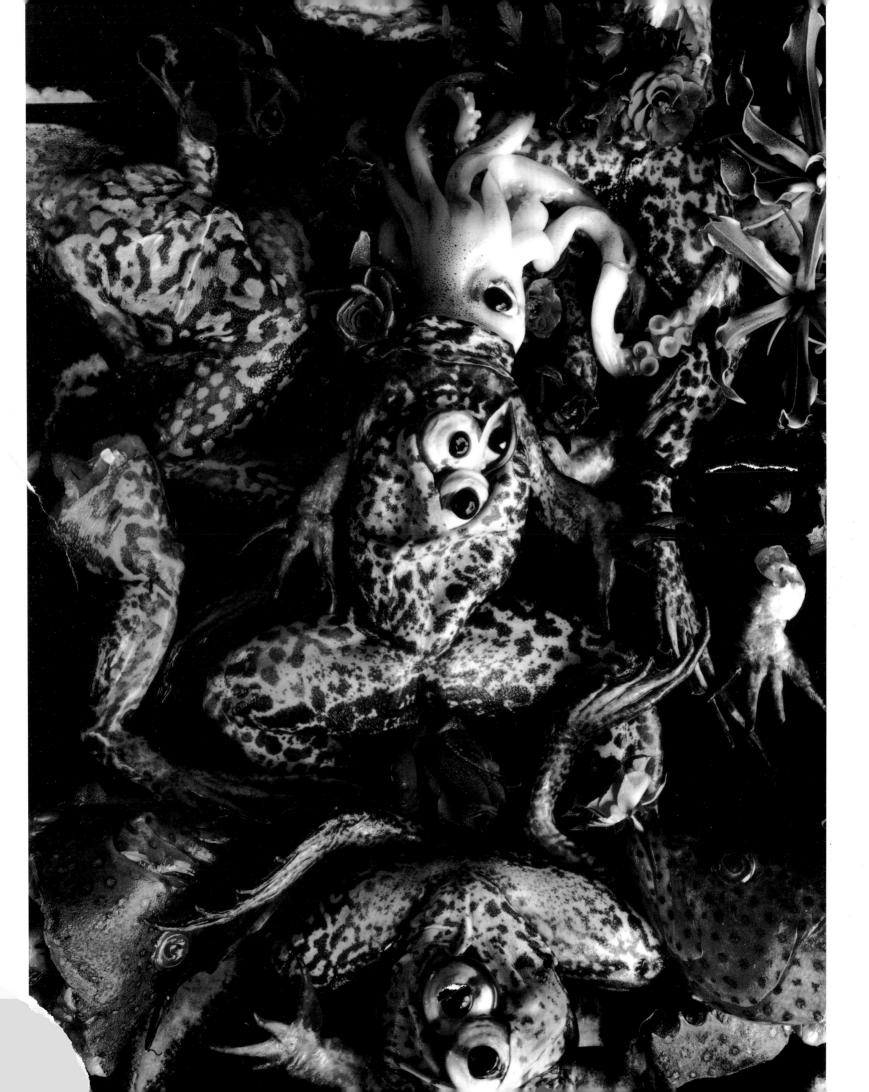

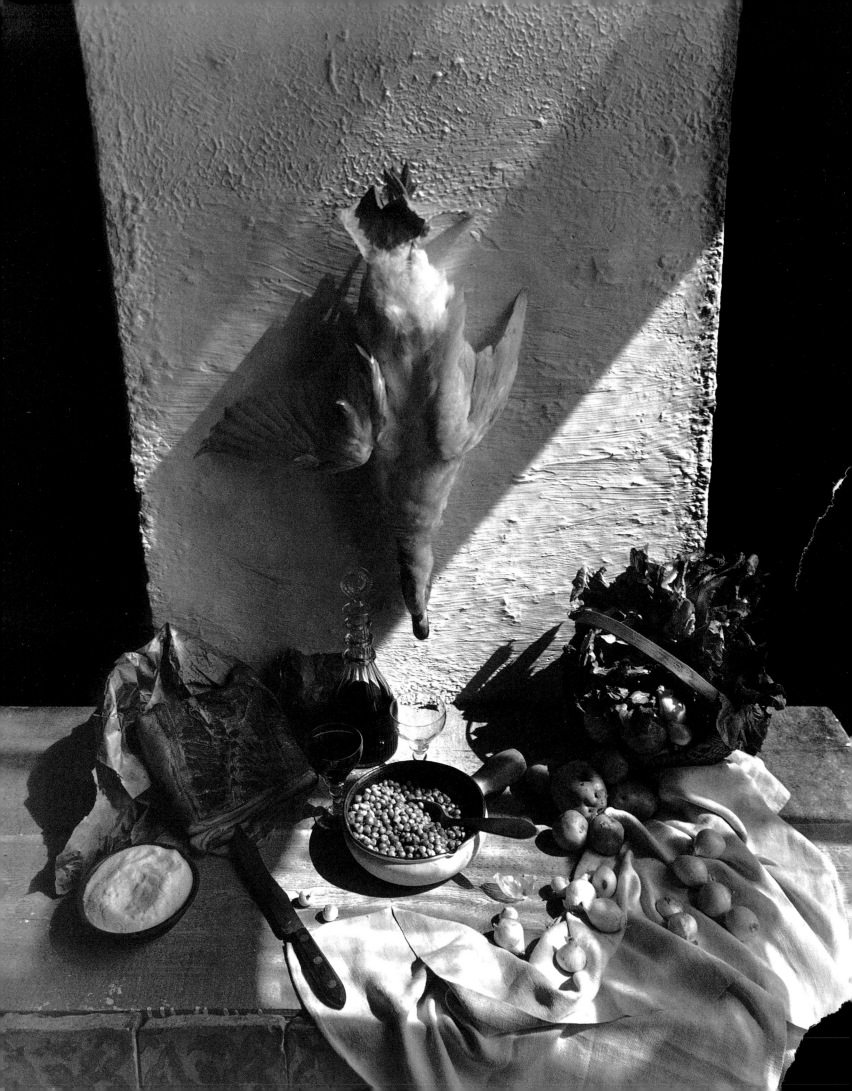

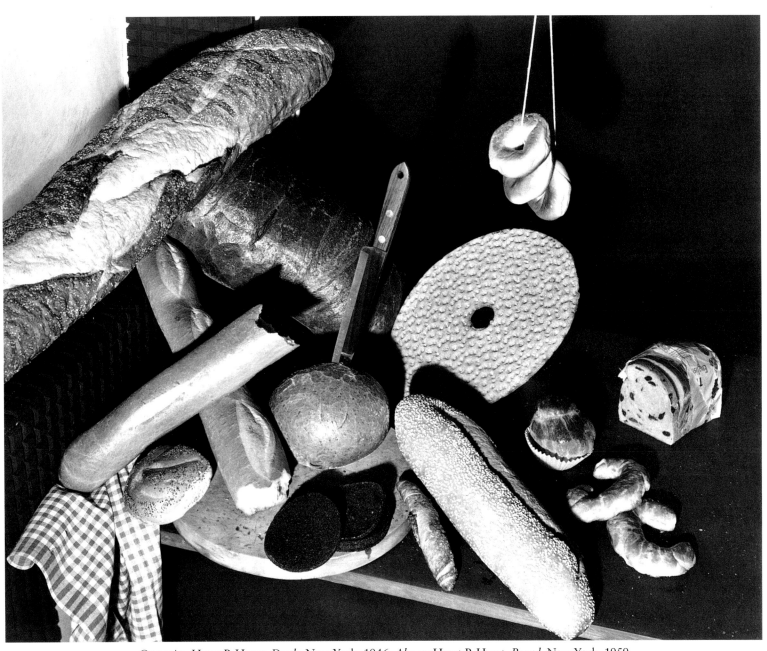

Opposite: Horst P. Horst, *Duck*, New York, 1946. *Above*: Horst P. Horst, *Bread*, New York, 1959

Pages 12–15:
Andy Warhol,
all images
Untitled,
from a series
of stitched
photographs,
1976–1986

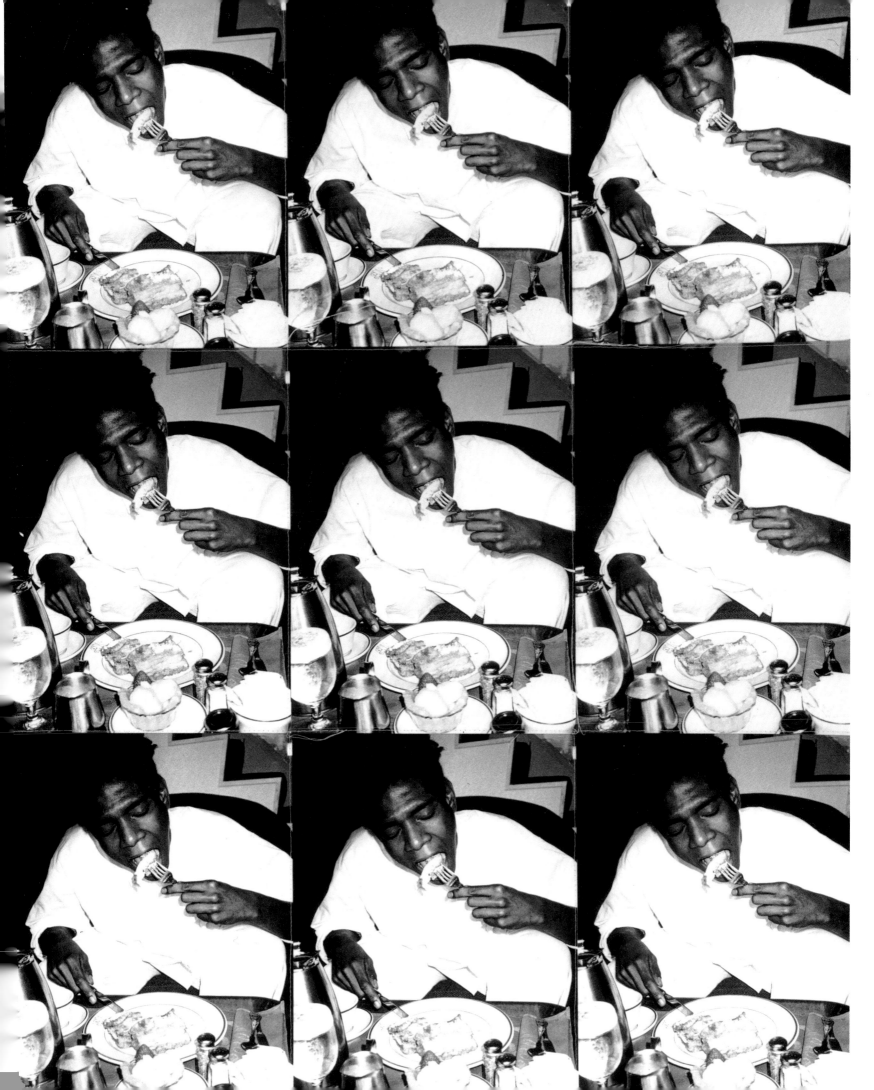

THE LOST MYTH OF GASTEREA

BY FREDERICK KAUFMAN

A century and a half ago, the stomach, the intestines, and the bowels held the most highly esteemed positions of all in human anatomy. That long and winding interior road from mouth to anus we now call the "digestive tract" was then considered the driving force of our lives and characters. So tremendous was the collective power of these organs that in his encyclopedia of gourmandism, *The Physiology of Taste*, Anthelme Brillat-Savarin insisted that Gasterea, a mythological being who presided over all the pleasures of eating and digestion, was no less than the forgotten tenth Muse.

The ancient Greeks counted only nine Muses. The sister deities were the combined NEH/NEA of their day. Each was, in her own way, a patroness of the arts or sciences: Clio funded history, Urania lobbied for astronomy, Melpomene specialized in tragedy, Thalia covered comedy, Terpsichore handled dance, Polyhymnia focused on sacred music; and the other three—Calliope, Erato, and Euterpe—combined to create a kind of literary Muse Mafia.

Men and women have been making all kinds of promises and sending up all sorts of offerings (burnt and otherwise) to these nine sisters for the last ten thousand years. How could Gasterea have missed out on all that fun?

Where had she been hiding?

The fact of the matter is that Gasterea did not reside for long among those distant, cloudy peaks of Mount Olympus. She escaped the ethereal realm when her sisters were still on formula. Left home the first chance she got.

Gasterea fled those interminable feasts of deep-fried nectar and parboiled ambrosia to live within the cankerous mouths and sour stomachs of human beings. And not one among the heavenly host could comprehend why their sweet little Gasterea had chosen to suffer the slings and arrows of outrageous indigestion. But Gasterea knew exactly what she was doing.

By making her home within that most private of all spaces—the stomach—Gasterea became the most interior and intimate of our gods. She became each individual's own, personal nexus of the spirit and the flesh.

Gasterea first came to earth as an animal spirit, a forest nymph frolicking among satyrs and dryads, hawking organic snacks at every tree trunk. But after a few thousand years of tending paleolithic fruit stands, Gasterea got bored. She cashed out, left retail and went into the wholesale sun, rain, and harvest biz. Gasterea became Demeter, the ancient world's spokesmodel for Nutri•Grain®. And everything was peachy until Hades, god of the Underworld, swallowed her only daughter, Persephone.

Which was when Gasterea got mad. If everything that lives, eats (she reasoned in her fury), then everything that eats, shall die! Gasterea's blooming cornucopias withered in winter's unrelenting darkness, and her sweet fruits and tender meats rotted into repugnant corpses. Once a fertility deity, Gasterea now dealt exclusively in fertilizer.

When the alarmed gods returned Persephone to earth (thereby creating Spring and all that comes with it), an appreciative Gasterea switched gears from fulsome to fruitful. Once again a goddess of rebirth and procreative power, Gasterea came out with a new line of gendered fruit and vegetable snacks: peaches, papayas, and pears; carrots, cucumbers, and corn on the cob. It was right around this time that Gasterea created those infamous apples . . . one single bite of which brought lust, temptation, and a booming market for aphrodisiacs into the world.

Gasterea had a good chuckle watching Adam and Eve slink out of Eden. She could have told them that ingestion inevitably leads to expulsion—if only they had asked. Food may have closed us off from paradise, but it has compensated by opening the doors of perception—from the first taste of mother's milk, to the book St. John ate, to peyote buds and magic mushrooms.

Gasterea's eventual merger with Moses brought not only manna from heaven, but an at-all-costs restriction against boiling a kid in its mother's milk. Poor Gasterea. Never before had she been forced to keep kosher! What a relief when Christianity finally showed up, even if this newfangled cult brought its own set of perplexing rituals to the table. Bread, wine, body, blood—could Gasterea tell the difference?

When the Puritans and pilgrims came to this land of milk and honey, Gasterea became an American citizen. She was here when Jonathan Edwards wrote ecstatic paeans to the sweet taste of God in his own mouth. She laughed at Ben Franklin's obsessive vegetarianism, then sighed at his obsessive capitalism: "Nothing but money is sweeter than honey."

After the Revolution, Gasterea became an acolyte of the diet guru Sylvester Graham. Graham had risen to national prominence by proclaiming that his "Graham bread" (precursor of today's Graham cracker) would have the same restorative effect on the chaos of Jacksonian America as it had had on his own digestive system. And less than two decades after Sylvester Graham published his highly neurotic food phobias to mass acclaim, an American doctor named Marx Edgeworth Lazarus took Anthelme Brillat-Savarin's gastronomic theories to their logical conclusion, and in so doing gave Gasterea her finest hour.

Dr. Lazarus argued for nothing less than an American utopia in which "gastrosophers" would rule. In his wacky masterpiece of 1852, *Passional Hygiene*, Dr. Lazarus declared that, "A skillful gastrosophist . . . will [one day] be revered as an oracle of supreme wisdom." Surveying today's oracular landscape of Susan Powters and Dr. Pritikins, one can only conclude that Dr. Lazarus's prophecy has at last come true. Indeed, from the first Thanksgiving turkey to the lacto-ovo tofu trays some of us presently graze, food has been the American eucharist, the road to both private and public perfectionism.

Which brings us to the present day.

Gasterea has paraded through countless millenia of human history—to end up managing the frozen food section of her local supermarket. Still single, living by herself in a suburban condominium, she stares at the ceiling in the middle of the night and wonders . . . was it worth all that trouble, only to preside over freeze-dried, pesto-packed Croissant Pockets®?

Gasterea inspired steak and potatoes, not Steak-EZE™ and Slim Skins™! Suddenly in a panic, Gasterea jumps out of bed and throws open the door of her Sub-Zero—and sees the cardboard vista of Lean Cuisines™ crowned by the withered remnants of a week-old Egg McMuffin™. And now Gasterea realizes the awful truth. She has been packaged and mechanized and vegetable dripped into a stupor. She has been commodified, capitalized, mass-produced, and mass-marketed into oblivion. Sure, she has an 800 number, a fax machine and a homepage on the World-wide Web. But no one takes her seriously as a Muse.

Unsuspecting peasants have been turned into trees for lesser crimes. Someone's gonna pay for this, Gasterea vows through clenched teeth. And, ready to unleash her fury on an unsuspecting, sleeping world, she throws on a sweater and some leggings, steps into a pair of black patent pumps, and marches downstairs.

However, before she wreaks her vengeance, Gasterea unaccountably stops to check her mail. The "Rent Mother Nature" catalog has been stuffed into the box. Gasterea tears away the plastic shrink-wrap to discover that with one phone call she can rent a maple tree, a bucket and private larder rights, and have the sap delivered to her door. She can rent a lobster trap, an oyster bed, a honey hive, a pecan tree. She can even rent a cow. Yes, "Rent-A-Cow," the catalog proclaims, "anytime!" (and for $49.95 extra, receive a framed cow lease). Gasterea drops the catalog and holds her head in her hands. She groans in misery and weeps hot, salty tears. Then, slowly and mournfully, she trudges back upstairs, and gets back under the covers.

Still, Gasterea cannot sleep.

"It's over," she murmurs to herself. "It's all over." But something is driving her to that table on the other side of her cold bed. And then she finds what she has been searching for. She brings the phone to her damp cheek, and, with trembling fingers, dials the "Rent Mother Nature" toll-free number. The myth might be lost, but she can still salvage a souvenir or two. And, for five extra bucks, Gasterea can get a snapshot of the cow.

Helen Chadwick, *Enfleshings I*, 1989, from the series "Meat Lamps," 1989–1991

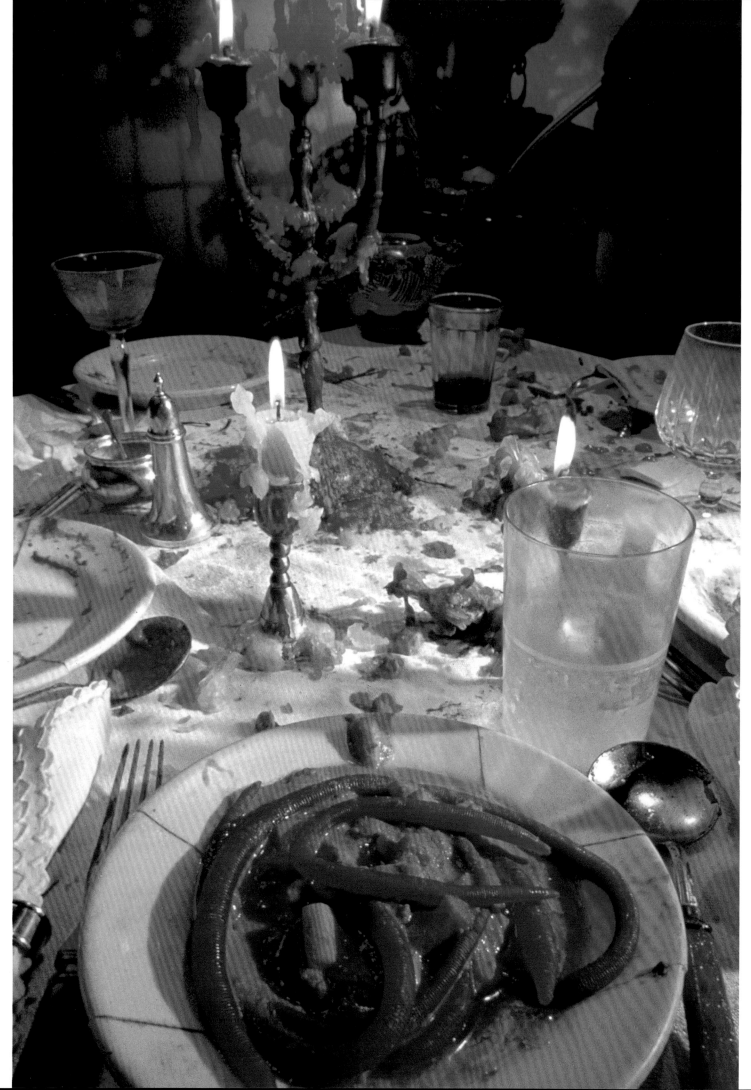

NAKED LUNCH — A FROZEN MOMENT WHEN EVERYONE SEES

Cindy Sherman, *Untitled*, 1987. *Opposite* Cindy Sherman, *Untitled*, 1990

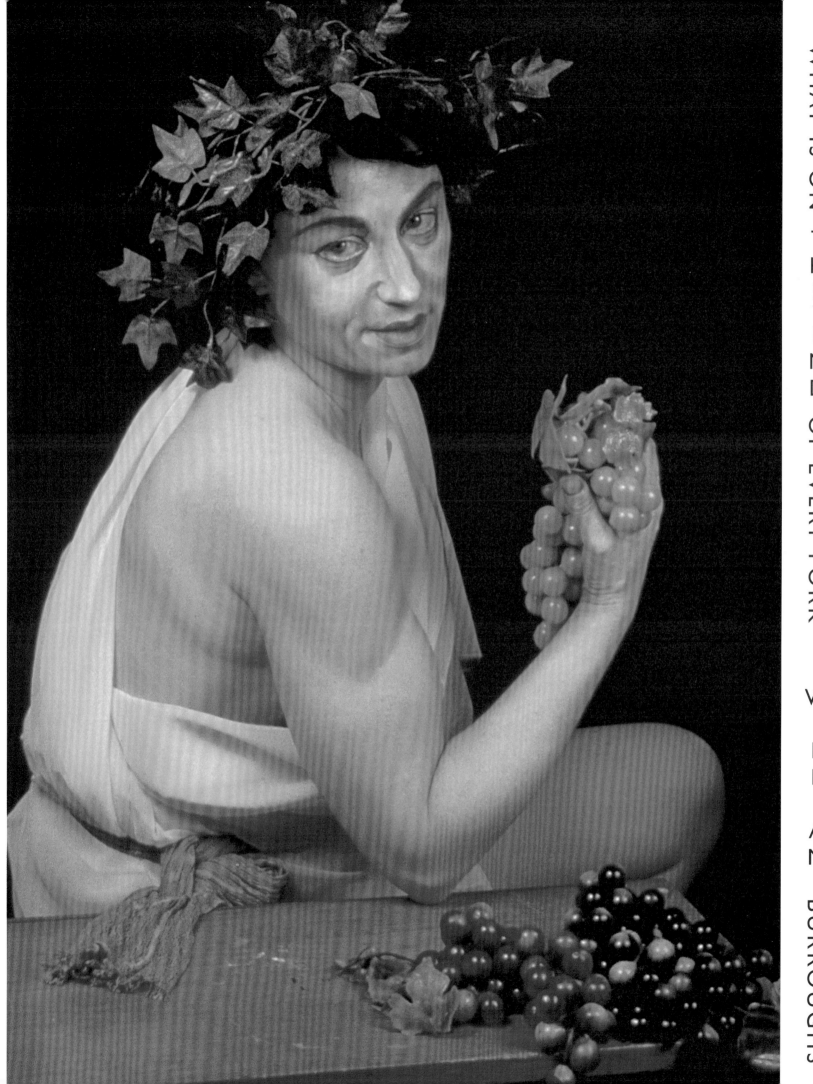

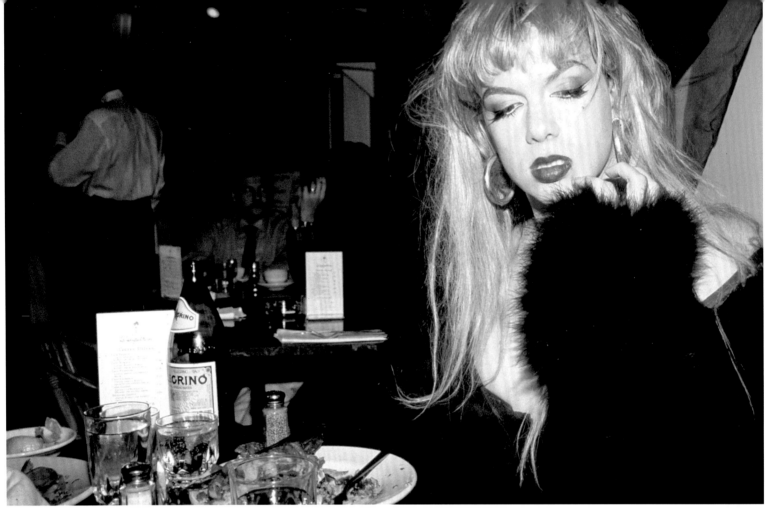

Nan Goldin, *Joey at Spaghetteria*, NYC, 1990

Nan Goldin, *Gina at Bruce's Dinner Party*, NYC, 1991

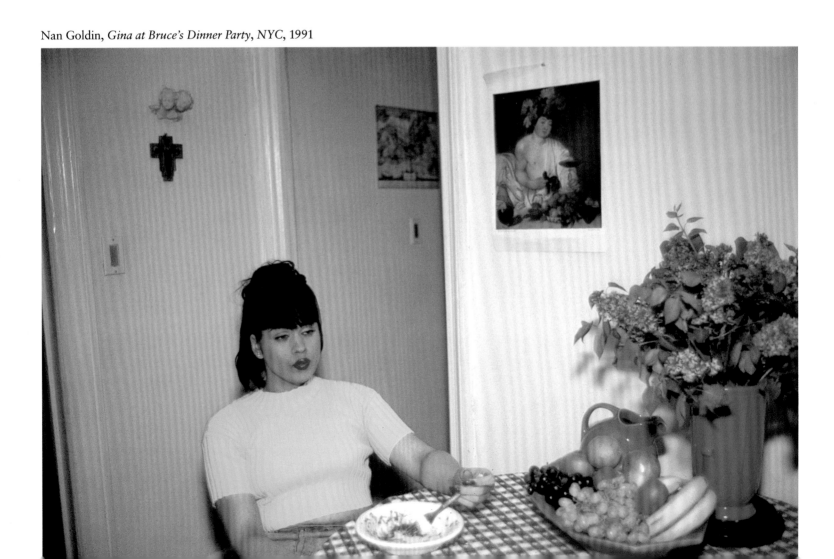

William
Eggleston,
Memphis,
ca. 1971

William Eggleston, *Sumner, Mississippi*, ca. 1971

Philip Jones Griffiths, Monk lunches on food provided by local people, Phnom Penh, Cambodia, 1988

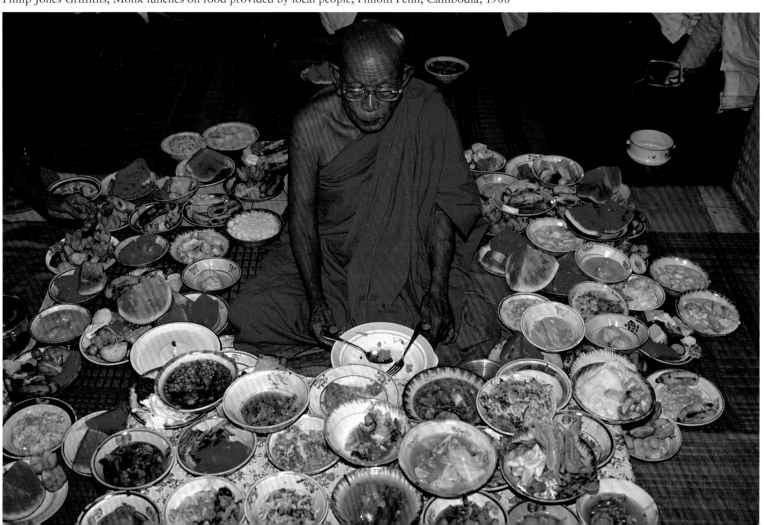

APERTURE: What's most important for you in food?

MARCELLA HAZAN: It has to taste good. If it's pretty, that's alright, but I look at my dishes for half a second and then I start eating. I want to be happy when I finish eating.

APERTURE: Do you taste while you're cooking?

MH: Not much. I smell, usually. I have Victor tasting my food. He is a very, very precise critic.

APERTURE: What are you looking for, Victor, when you're tasting?

VICTOR HAZAN: Pleasure. It seems to us that pleasure is becoming less and less important in contemporary life, and in the cultural subconscious.

APERTURE: What makes you think pleasure isn't part of the culture? Most people, I think, like to eat.

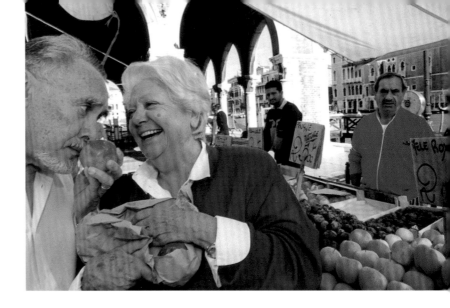

MARCELLA AND VICTOR HAZAN

VH: They like to eat, and certainly people are talking about food more now than they ever have before. But though they know when something tastes good, they don't know when it tastes bad. [Laughter] I think the dishes of all established cuisines encapsulate a pleasurable experience. And if they're done with sensitivity to their tradition, they will repeat that experience for everyone. What's happening in this country is the reverse; people are making dishes, hoping the dishes will give rise to an experience, and they don't, because all this comes out of nothing.

MH: Until I married Victor and came to this country, I never cooked in my life. And I had a husband who wanted to eat, so I tried to repeat what I'd eaten in Italy. I think I knew it by osmosis, by back memory. My tradition of food was there, so it came out. It wasn't easy, but somehow I managed to make an Italian meal twice a day.

In America they don't have these roots. So they swim between one thing and another, and they get very excited, yet the adjectives they use aren't really about food—"beauty," "color," "texture."

APERTURE: Do you think Americans get a kind of bastardized Italian cooking?

MH: Twenty-five years ago, the Italian food here was the food that immigrants brought to this country. And those immigrants often didn't have good cooking, because they didn't have money. When they arrived in America, they built up a cuisine that wasn't really Italian—pasta many times overcooked, a lot of sauce, especially tomato sauce, cooked for an hour, which ruins the tomato, and those big portions—because they were starving!

Italian chefs who arrive in America don't cook like they cooked in Italy, because they think they have to please the customer. And the customer doesn't know what Italian food is, really; he has a strange image from what the immigrant brought. So with pasta they put in sun-dried tomatoes, which are used like pickles in Italy; they're never used in sauce. Or maybe they give him an espresso with lemon peel. In all of Italy you will never have espresso with lemon peel, but Italian immigrants could not at first afford coffee, so they made coffee with chicory, and to cut down the chicory taste they put in a lemon peel. Then later, when they could afford to buy coffee, they kept the lemon peel.

APERTURE: Is there a quintessential Italian meal?

VH: The problematic word there is "Italian." That word has no meaning except outside Italy. In Italy, nobody calls themselves Italian; they call themselves Florentine, or Neapolitan, or Venetian. A quintessential Venetian meal would be seafood, and it would be delicate.

MH: A quintessential Tuscan meal would be soup. There wouldn't be pasta. Tuscany has a wonderful tradition of soups, meats, stews—robust, rather salty cooking. Whereas when you go to the south you have a tradition of pasta, like spaghetti or macaroni or ziti or penne. Or go to Bologna, and there the pasta is made by hand on a rolling pin, and requires butter and cheeses —and the pasta would not have olive oil.

VH: Italy's various dialects are a good analogy: you know a Neapolitan can't really understand a Venetian. Food is similar.

APERTURE: What about a person who knows nothing about cooking but just likes to eat? How do I know what to do when I get to the Rialto market?

MH: You follow a good Italian cook. But if you have a palate, after a while you realize what will go together and what won't. First you have to know the way ingredients cook, and how they react together. You also think about the taste, if it's too hot, too bland, or what. So if at the market you see the most beautiful peas—let's say, very green, very sweet—you think, "Well, the peas are very good. Now how can I use them? I can use them in a sauce for pasta, I can use them in risotto, I can use them to make a stew, or for a side dish." And at the same time you have beautiful asparagus. Now asparagus and peas won't go together as a vegetable dish. So you decide to make the pasta sauce with the asparagus, or the risotto with the asparagus.

APERTURE: Are there other qualities that define a meal in Italy?

VH: In Italy, the midday meal is the central event of the day. You eat in the daylight. It's very different from dinner. You know that the table where you eat in Italy has a special name?

MH: It's the *sacro desco*. The desco is the table where you eat, but it's *sacro*, sacred.

VH: All of Italian life is centered around this happening, this interruption in the day. Nothing can replace it.

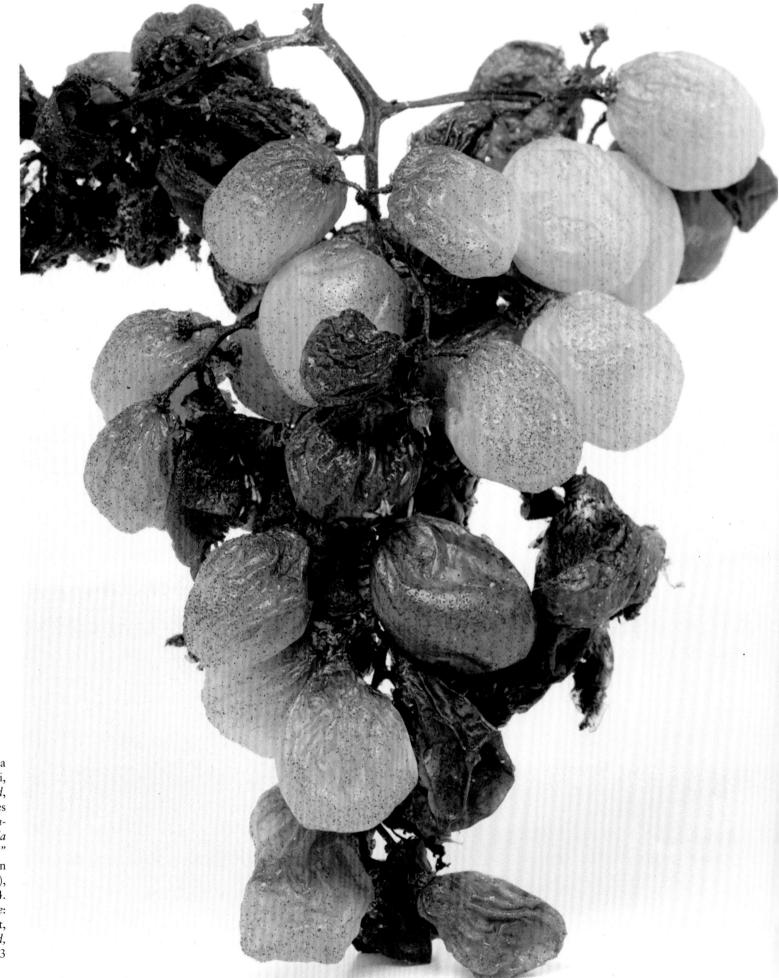

Bruna Ginammi, *Untitled*, from the series *"Decomposizione della materia"* (Decomposition of material), 1994. *Opposite*: Robert Flynt, *Untitled*, 1993

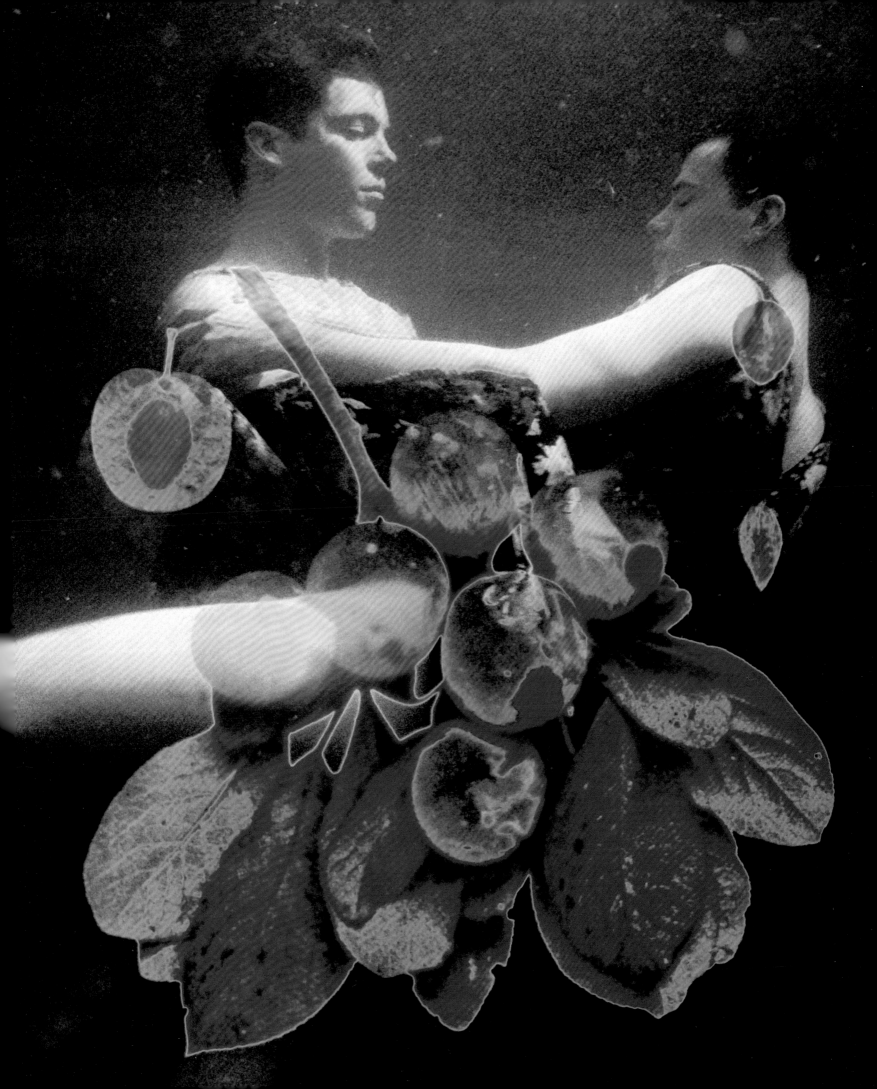

sounds good," you know? And then I break them down when I wake up—if I can remember them.

APERTURE: What matters to you in food?

BF: Texture is just as important as flavor. It's so important to have more than one texture. There are surveys of what sells on menus, and the number one adjective is "crispy." I order crispy things all the time. It isn't even about what the food is; it's just that it's *crispy*. It's crunchy. It's crusted. Any of those things people want.

APERTURE: I had this vision of you starting a dish with all your squeeze bottles of sauces.

BF: Jackson Pollock–style? The sauces may look like they're everywhere, but where they are on the plate is actually calculated—not to the exact inch, but there's definitely a place for them. It can look sloppy otherwise.

APERTURE: I know you're really high energy. Is cooking very physical for you?

BOBBY FLAY

BOBBY FLAY: Blue corn is a very cool ingredient. It's blue, and it's flavorful, and it's organically grown, and it's only grown in the United States, in New Mexico. I'm a food patriot.

APERTURE: Is there a difference between what you like to cook and what you like to eat?

BF: Sometimes there is, because I cook for my customers. I pride myself on understanding how to feed New Yorkers. In any good restaurant, ten percent of the people who come in are foodies, and too often chefs spend a lot of time taking care of that ten percent. They get some exotic bird from Scotland, and how many people are going to order Scottish grouse? Well, half of that ten percent will. The other ninety percent are going to order chicken and salmon.

APERTURE: So there's a conflict, then, between your business and your role as an artist?

BF: I don't consider myself an artist. People say, "You're an artist, you're a chef, these plates look beautiful," but I think an artist really studies their art, and I don't do that. I think food is food, and it's just food. It can taste good, it can taste bad, but it's food, and people have to eat. You know, my roots in the restaurant business come from working in a Broadway-district restaurant that was not about food, it was about *feeding*.

There are chefs all over New York who dedicate their lives to becoming four-star chefs. If you wanted to give me four stars, I wouldn't take them, because that's not the kind of restaurant I want to run. My restaurants have two things: good food and high energy. I don't want to own a quiet restaurant. I don't want to own a temple.

You know, great chefs are prisoners to their stoves. And I don't want that. I love creating food, but it's not just about making the perfect timbale of lobster.

APERTURE: Let's focus on creating food.

BF: I actually dream about finished dishes. I see the dish garnished, plated, and ready to leave the kitchen—"Hmm, that

BF: It's very physical. I was an athlete in high school. I don't know if that has anything to do with cooking, but maybe it does, because I like it when it's very busy, and everybody's sort of sweating; there's an adrenaline that goes through you. When it's slow, it's less work, but everybody hates it. It's boring. You're not cooking well. When it's busy the food looks great and tastes great because you're not even thinking about it. Everybody just performs better.

APERTURE: What about food and sex? Are they related?

BF: They've been related since the beginning of time.

Half of my kitchen staff are women. It's always a well-balanced man-and-woman kitchen. And they talk about two things: they talk about food and they talk about sex.

APERTURE: At Mesa Grill you're doing a take on an established cuisine. It's your Southwestern. Bolo seems different: you've taken Spanish food, Portuguese food, Catalan food, and you've created a very personal cuisine, a real signature.

BF: Obviously I like Latin flavors. They offer ways to get flavors into food without using fat. Originally Mesa Grill was Southwestern and Mexican influenced, and Bolo was—well, Bolo is controversial. I told a journalist before we opened that I was going to feed New Yorkers the way I think Spanish food is supposed to be eaten. But people get so serious about authenticity. Who cares?! You know? Did I say I was opening an authentic restaurant? I'm Bobby Flay, I grew up on Seventieth Street and Third Avenue, I was born in Lenox Hill Hospital. Leave me the fuck alone. I'm making food here. And they know that, and they don't care. So at first I was like, "Just back off. Just taste the food and eat it." Everybody said it was delicious, but nobody could figure out what to call it. I say it's food.

APERTURE: When you're creating cuisines that aren't traditional and aren't necessarily your own experience, how do you know when you have it?

BF: I just know it.

APERTURE: My guess is you love the Tokyo fish market.

NOBU MATSUHISA: Yeah. Every time I stay in Tokyo, I wake up in the morning about six or seven o'clock, I go to the fish market. See fish all over. They also have a lot of fish swimming in tanks—the customer says, "I'd like this fish," and they send it to the restaurant. Then, you know, there are breakfasts, sushi, noodles, all different kinds of food in the market. In summertime they have a Japanese sea bass that's very beautiful, and red snapper is beautiful. Of course Japanese yellowtail is beautiful. All the different fish they have, it's amazing. I do like to see all the different kinds of fish, and shrimp, eel, octopus, abalone, white clam.

APERTURE: You don't have a favorite way of cooking? A favorite cuisine?

NM: Oh, I like Japanese food. I grew up on Japanese food. I am a chef, so I eat everything—French, Italian, Chinese—and I use a lot of influences in my food. But basically I love Japanese food.

APERTURE: What other cuisines interest you?

NM: I like to use all different influences. I use shark fin, a lot of Chinese influence. I use truffles, caviar, and white truffle oils.

APERTURE: You had rigorous traditional training in Tokyo, but you cook in your own way—your sushi is in your own style.

NM: Well you know, of course, I can do it the traditional way, because I am Japanese. I learned from our traditional way. But after I grew up in Japan, I came to the United States, and I opened my business—but for different customers. In Japan, a lot of people want the traditional way. But in the United States a lot of people still don't like raw fish. So I do it my way. Now, how do you let the customer get what they want? I ask the customer, "So how do you like it?" People say, "Hey, Nobu, make it for me this way." Okay, I try. You know, I am professional. I know the basics of cooking. Plus the customer gives me ideas.

APERTURE: Are you less an artist than a businessman satisfying the customer?

NM: I am a chef. That means I'm always thinking about trying to do my best for the customer. A lot of people come to my restaurant. If it makes them happy, they come back. Sometimes with a friend. You know, customers follow me, so money follows me, and I never think about business—or maybe a little, but it's not too important to me. What's first with me is the best food. Then next is the customer is happy.

I don't think of my food as art. Of course, beautiful is better than ugly. But my food has to be served hot. So there's not too much digression. At a lot of Japanese restaurants there's digression—it looks gorgeous,

nice presentation. My food is not like that. It's beautiful, but we try to do the best in a short time. Example—okay, you come to the restaurant. You're hungry. You want service immediately, right? Everybody's the same. You don't want to wait a long time. Because we are professional, we have a lot of technique with food—we can make beautiful presentations. But food is speed. Hot food has to be served hot. It's my food, but in the short term it's always, "Let's try the best technique, the best service."

APERTURE: In that description, your work as a chef and, we'll say, as an artist begins with technique.

NM: Technique is never finished. A chef is professional the way a baseball player or basketball player is professional. I've been making sushi for twenty-eight years, but I'm still learning. So, example: last night, one of my best customers and his wife were here for their twenty-sixth wedding anniversary. I asked him, "What would you like tonight?" He said, "Anything you want." So he challenged me. So, "Okay, thank you." As I'm beginning, okay, I have no idea. But I'm thinking about this customer, what he likes. And I don't go by the set menu. As I serve the food, I watch them. . . . Maybe they like it. I can tell. People eating, biting—there's a happy face, you know, a smile. So maybe they like this flavor, this temperature, this fish. So this is my way.

APERTURE: So it's spontaneous. You decided what to make as they were eating it.

NM: That's right.

APERTURE: Is there anything you dislike? Do you like snake?

NM: No way. No way. It's too rare.

APERTURE: What food do you crave?

NM: Well, it's . . . I like noodle, especially the buckwheat noodle, it's a different kind of flavor, and cold and hot.

APERTURE: What's in the future?

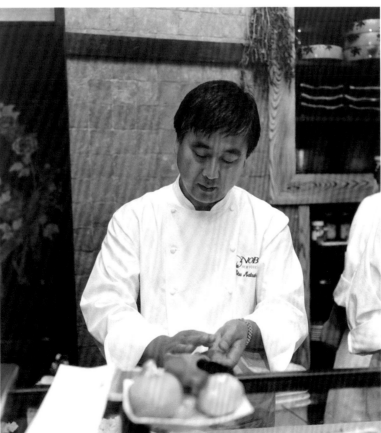

NM: The future? I'd like to try to keep going. Being a chef is my life. I don't want to stop. If I find a new influence, I may try it. Sometimes I don't know how I can use it, but I'm never shy; I may ask a friend who's a chef how I can use it, or how he uses it, he teaches me, "Use it this way," and then I try to do my food. That's my style of cooking.

I started the chef life when I was eighteen. I am forty-six now. I never think about another business. The chef life is my life. Cooking is my life. I'll still love cooking another twenty years, I hope another thirty years—until my life is finished. I like this job. I like working. I like cooking.

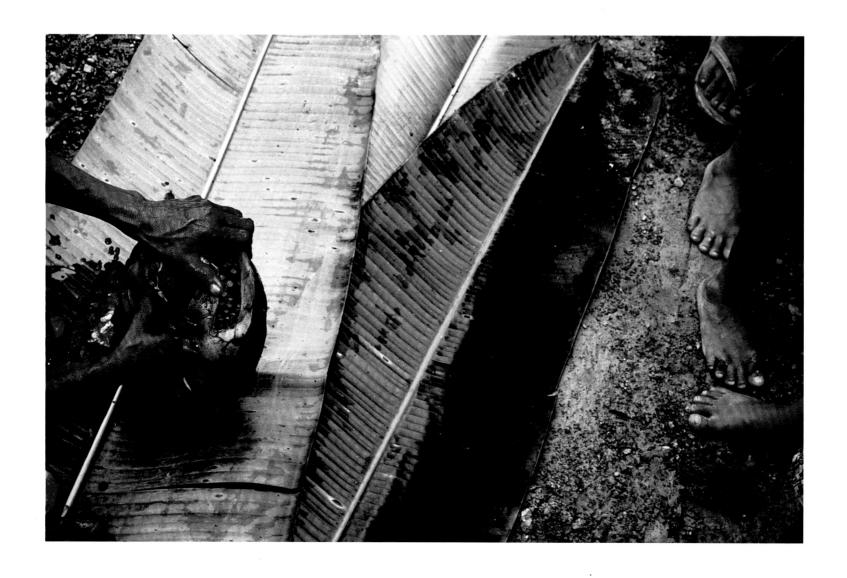

what was her na**M**e
(she lived in the countr**Y**)?
she **C**ouldn't
d**E**cide
whether or **N**ot
the mushroom w**A**s edible. she

tele**P**honed to say:
don't eat it, it may be poisono**U**s.
mothe**R** replied:
don't be foolish, it w**A**s delicious.
—John Cage, from the *Mushroom Book*

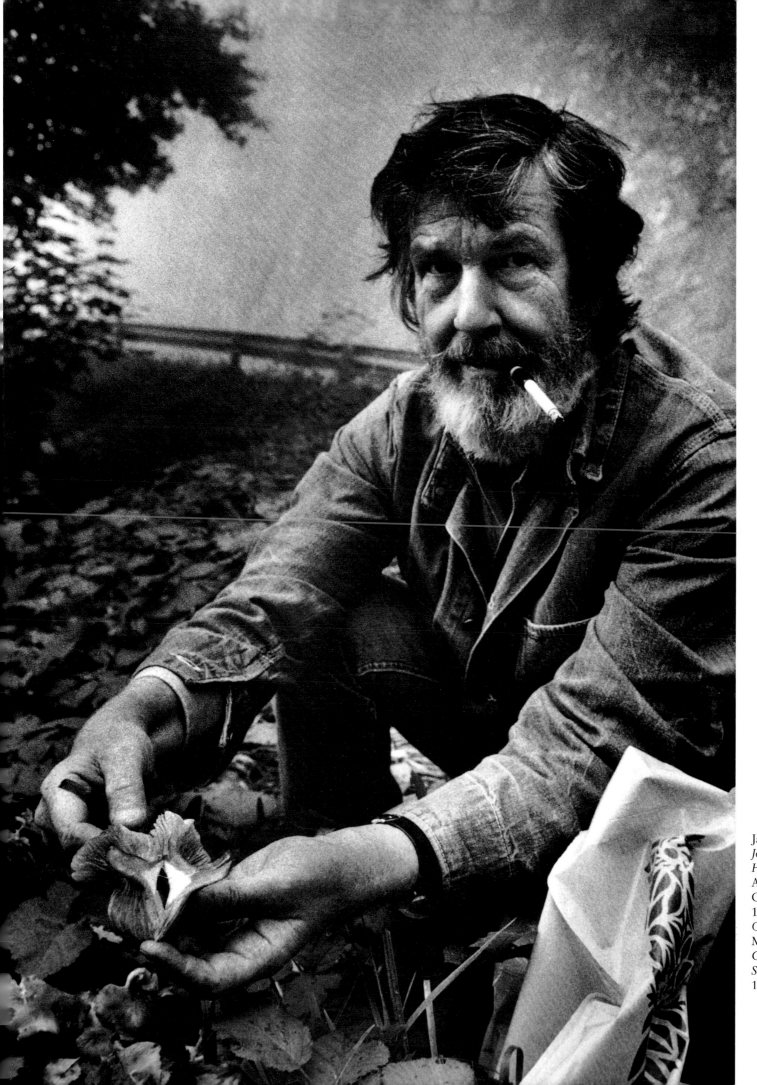

James Klosty,
John Cage
Harvesting
Armillaria mellea,
Grenoble, France,
1970.
Opposite:
Miguel Rio Branco,
Gorotire—
Sul do Pará,
1993

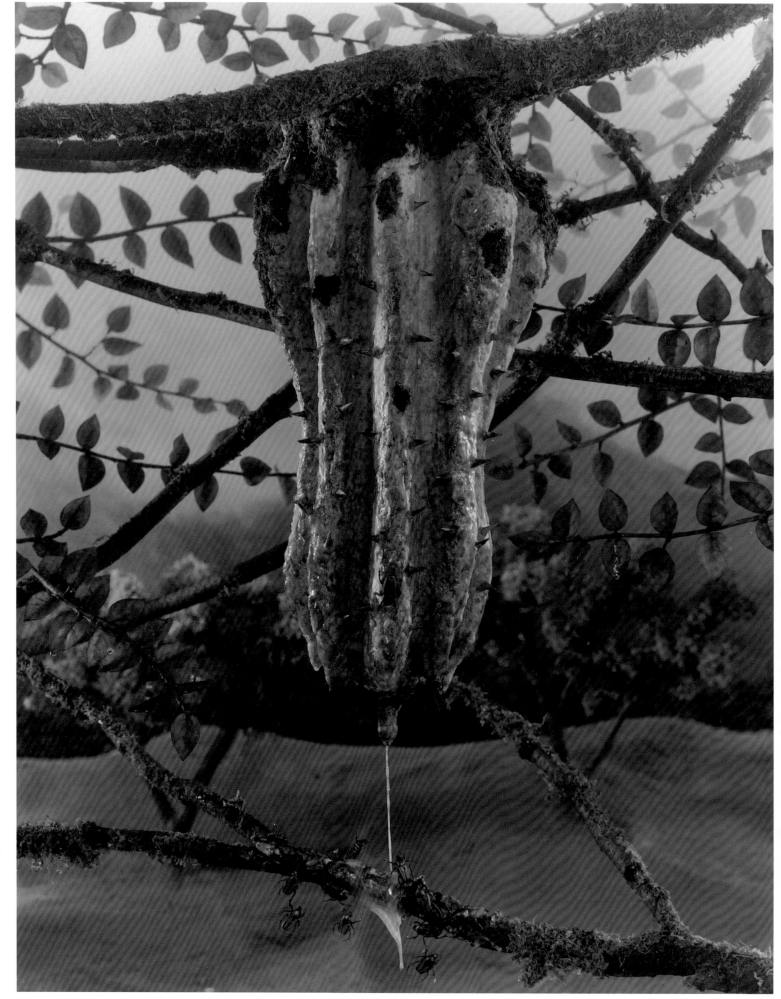

Gregory
Crewdson,
Untitled,
1993.
Opposite:
Gregory
Crewdson,
Untitled,
1992

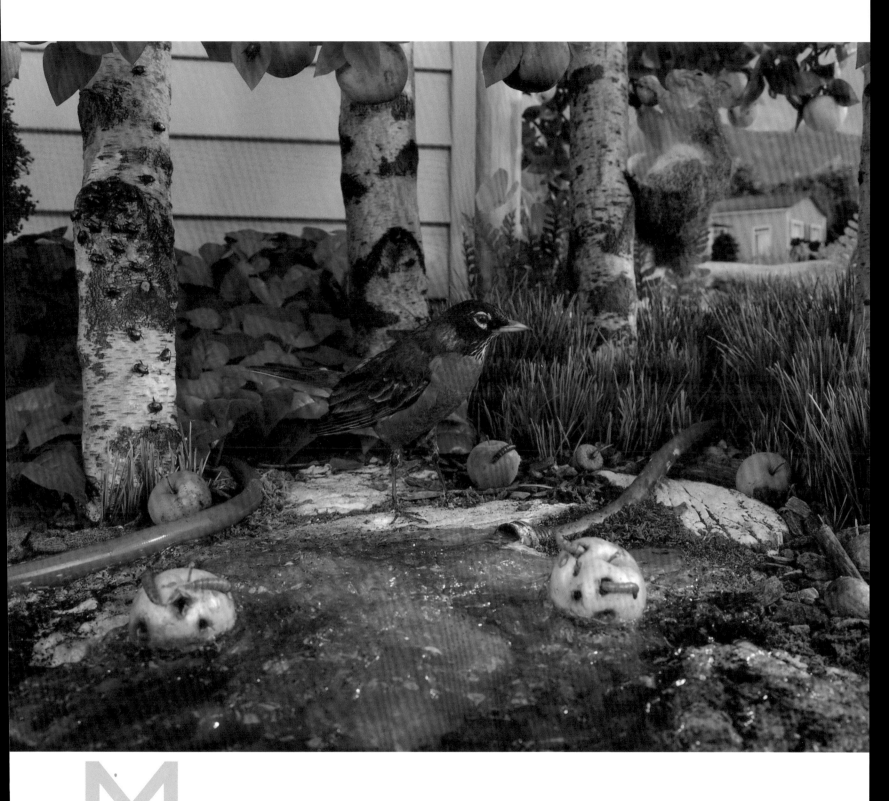

MURDER WE MUST. IF NOT COWS AND PIGS AND FISH, THEN CABBAGES AND RUTABAGAS. WE FLAY BANANAS, VIOLATE OYSTERS, RAVAGE POMEGRANATES. OUR LOT IS BEASTLY AND THERE'S NO HELP FOR IT, FOR FEED WE MUST ON CREATURE KINDS. OUR HANDS ARE STAINED WITH CARROT BLOOD AND NOT ALL THE SEAS OF NOAH'S FLOOD WILL WASH THEM CLEAN, NOT AFTER GOD'S PACT WITH NOAH: "EVERY MOVING THING THAT LIVES SHALL BE FOOD FOR YOU." THAT'S A LOT OF TERRITORY IN WHICH TO ASSERT OUR PUNY MANHOOD AND DECREE THAT THIS IS FIT AND THIS NOT, THIS FOOD PURE AND THAT DIRTY. NO, ALL THAT LIVES IS FOOD FOR MAN WHO, DEAD, IS FOOD FOR WORMS. THAT'S THE DEAL. —BETTY FUSSELL FROM "ON MURDERING EELS AND LAUNDERING SWINE"

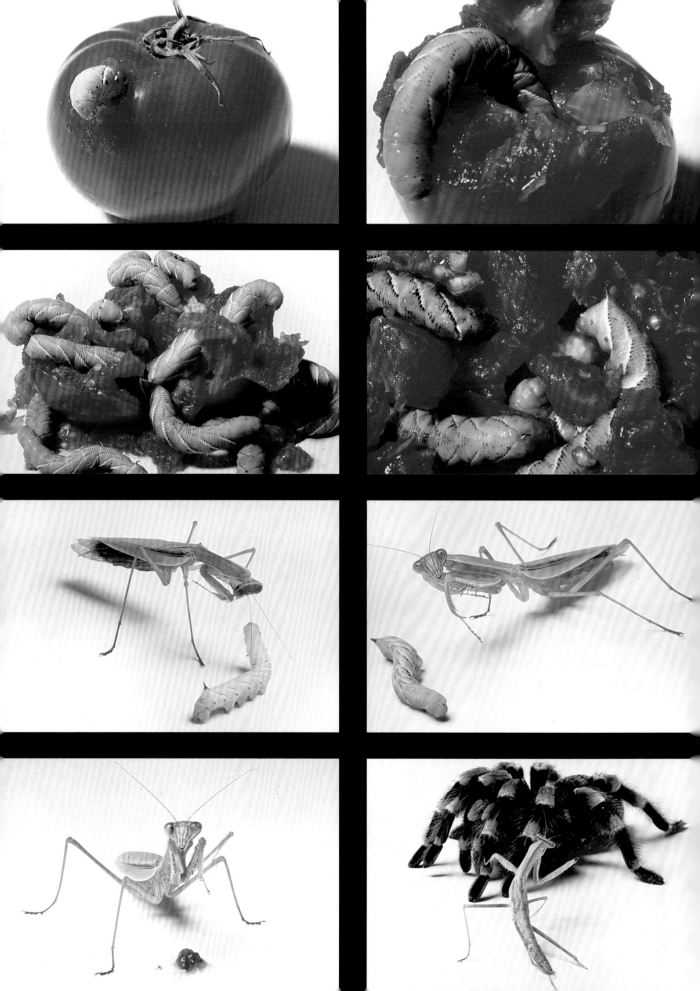

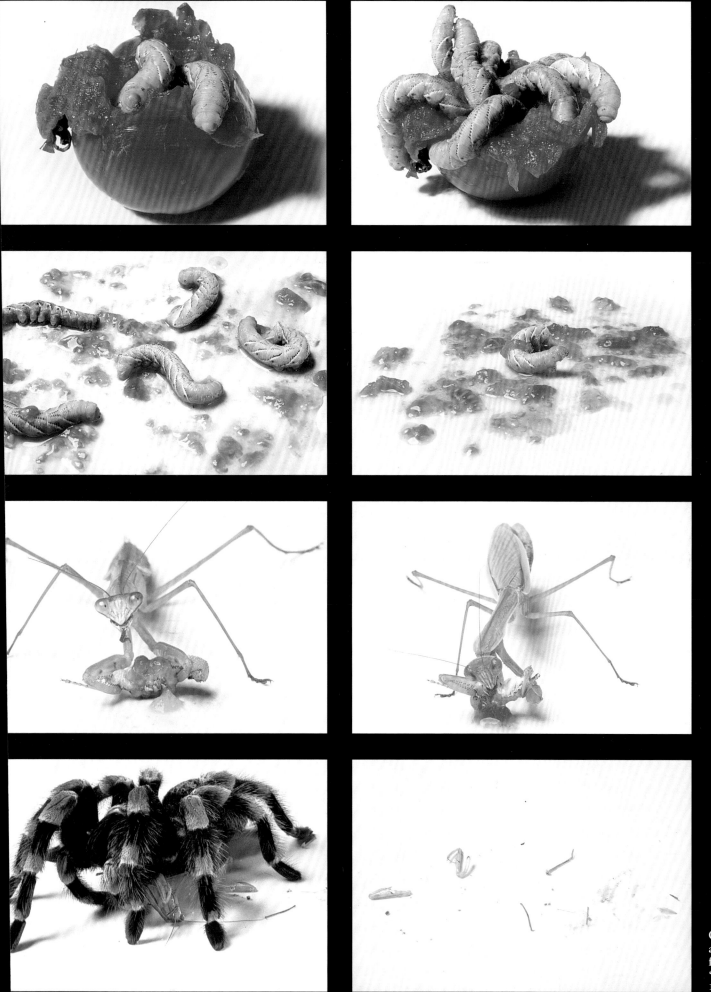

Catherine Chal
all images
from the series
"Food Chain,"
1994–95

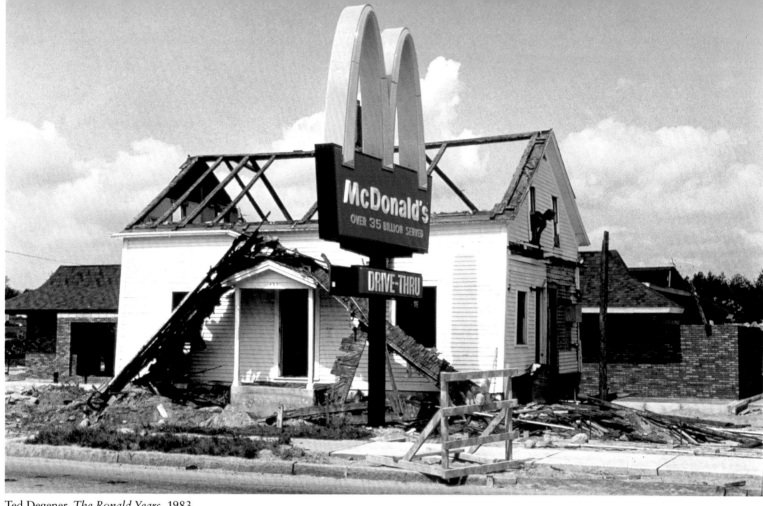

Ted Degener, *The Ronald Years*, 1983

Ken Botto, *Culture Clash*, from the "Paris Series," 1990

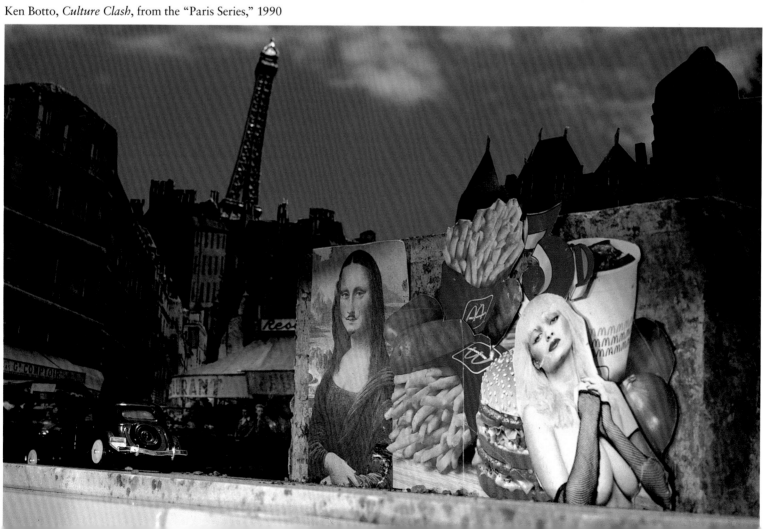

Jack Carnell, *Liza at Andy's Birthday Party,* 1989

Jill Graham, *Rick's Pig Roast,* Hampton, New Hampshire, 1995

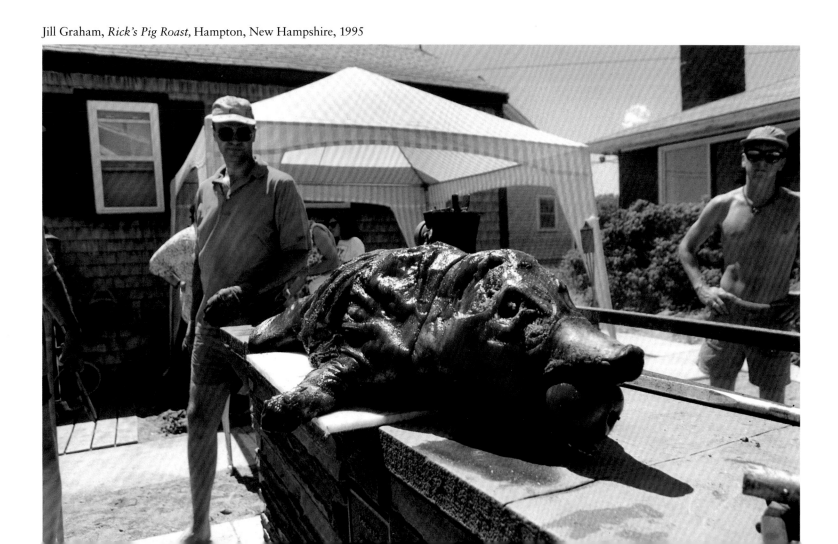

ROSE LEVY BERANBAUM

APERTURE: Do you have favorite flavors, or combinations of them?

ROSE LEVY BERANBAUM: Mm-hm. I love flavors, their purity and their interaction. Lemon is one of my favorite flavors. And then there are certain things I've discovered, like that vanilla is flavor-enhancing, and makes other flavors more intense. And walnut makes chocolate more chocolaty.

APERTURE: Tell me your feelings about baking.

RLB: Pastry is like an artist starting with a palette of colors: nothing ends up looking the way it started off looking. So you feel a sense of magic about it. And it's really so few things—sugar, flour, butter, chocolate. Yet look at the huge realm of shapes and textures, and how the texture influences the flavor, and the flavor introduces your sense of the texture, and it all works together. The pastry world has so many aspects. It's visual and it's scientific, and it's the fact that you can make a thing wonderful, and it's truly creative and yet repeatable.

APERTURE: There are obvious analogies between science and baking as you practice it. The goal is precise, repeatable experiments that other people can duplicate. There's a limited set of materials. Measurements and implements are all defined.

RLB: You have to have a scientific knowledge of ingredients. You must know how much water there is in a banana, how much sugar, what the components of white chocolate are. If you understand the science of the way these ingredients work, then you're not a slave to them.

When I studied so much what was going on during baking, I found I was enjoying eating more. I felt like I'd entered the microcosm of the cake—like I was sitting there with the gases bubbling around.

APERTURE: So are you an artist or a transcendent scientist?

RLB: Well, I started off saying I was an artist type. I have an artist's temperament: I'm impassioned about stuff, I can't control myself. But the truth is I have a scientific, logical mind. A lot of people think of bakers as fanatics who stick to the rules. But it's just a different type of creativity. And you have to taste the ingredients in baking, too. Baking isn't as rigid as it sounds. But I do think it attracts a different kind of personality.

I also think there's another commonality in bakers—they're really people who want to be loved. Because there's no surer way to be loved than to bake. Give somebody cake and they're yours.

APERTURE: You've described a nexus where flavor and design and structure and smell all come together. How do you know when you're there?

RLB: When people moan when they eat. I mean, my achievement this summer was making a twelve-year-old boy moan. And they don't moan over food! They'd moan over a new hockey helmet or something.

APERTURE: You're talking about a visceral experience, a physicality of eating.

RLB: Yes, but I have to say I often feel I have the better part of it in the making of it. Smell is so important—if I had a choice between taste and smell, it would definitely be smell. It's the best part. And when you're baking, not only do you get the creativity and the handling and the mixing but you have the aromas.

APERTURE: Is there an erotic aspect to food?

RLB: Both food and sex are sensual, physical, or emotional. They're two intense experiences, but to put them in the same cubbyhole is a limitation. I love sex and I love food. Life has a huge range of experiences, and they're all to be embraced without having to be merged.

APERTURE: Are there spiritual elements in your baking?

RLB: My whole approach is spiritual. Baking is my connection to the world. I once thought that eating was as personal as making love, and that people really shouldn't do it in public. So I used to prefer eating alone, but now I find that food isn't as important to me as people, and the sharing of the experience. I used to think of cooking as like a work of art, but no! It's a live thing. It needs to be eaten at the right temperature, in the right environment. It tastes just in accordance to how you're feeling. Eating and cooking are all about connection with other people.

I think life is better than any food you can imagine. Although there are times when I question that, because I'm so dramatic. I'm the kind of person that if I'm deeply disappointed, I will say "Non voglio vivere!" Did you ever see *La Strada*? She's saying, "I don't want to live any more, I don't want to live," and all of a sudden you see her smile because you realize she's found the essence of life, that even though you're totally devastated, when it comes right down to it life is the best thing we have, and everything else we can live without.

APERTURE: Even desserts?

RLB: [Laughs] Yes.

Laurie Simmons,
*Four Petits-Fours
(studies for
walking cake),
Green,* from the
series "Four
Petits-Fours,"
1989.
Pages 38 and 39:
Martin Parr,
all images
Untitled, 1995

APERTURE: You are the queen of wedding cakes and other fancy cakes. Where do you get your ideas?

SYLVIA WEINSTOCK: Sometimes the customer gives them to me. The customer will say, "We're doing a wedding in a garden, and we're using twig baskets filled with wildflowers. Can you make a cake with that look?" Whereupon we sit down and design something together, and if she's adventurous enough I'll make her a cake with a twig look.

APERTURE: Are your flowers fantasies, or do you do research?

SW: The flowers we make are botanically correct. We look at flowers and we see whether we can replicate them in sugar. Or people say they want a cake with a trout in a stream, so we find out what kind of trout, and what kind of flies that trout will open its mouth for. We once did a cake that was like a potted orchid, and I understand someone said to the butler, "Please be sure to water the plant."

APERTURE: You're an artist—a painter, a sculptor. Do you also see yourself as a performance artist?

SW: I'm a visual artist, I think. We make something tangible. It's carved, out of sugar or marzipan. We want you to have the memory of something of wonder.

What we do, though, is not an isolated thing. It's visual but you can also touch it. You can smell the vanilla, the sugar, the butter. So we're attacking all of the senses: touch, sight, smell, taste, and of course, though I don't think memory is considered a sense, it's there—you'll remember it forever.

APERTURE: Tell me about your physical process—the baking and cooking, the lifting, the stirring.

SW: The cake is baked the day before you eat it. After it's cooled a little, it's removed from the pan, and it's wrapped in a plastic bag to cool enough for us to handle. Then it's sliced: the baker cuts off the top and the bottom, so that we end up with the cake's interior. (We only want the best part, which is the center.) Then it's filled with whatever flavors the client has chosen. We make a stock buttercream, we call it the "mother," which we then flavor per cake. If it's a busy week we may

have ten big bins of mother. And if your cake is to have a mocha filling, they'll take out enough mother, mix it with the mocha. After the cake is filled, it's refrigerated, so it's firm. Then the icing department envelopes each tier in a pure buttercream icing made of egg-white, sugar, and butter—that's it. Then it's refrigerated again until it's firm and cold.

Next it's put on a support system—if you have one cake sitting on top of another, they have to have an internal support so they won't collapse. After it's assembled it's chilled again. Then it's brought to the decorators, with whom I work very closely. The decorator looks at her work sheet, which will say, "We're using pink roses, a lily, delphiniums in blue." And we'll assemble the flowers, which have been made in advance. We'll look at the sketch I made with the client. Does she want a nosegay? A loose, drippy, English-garden look? Something formal? What's the feeling? You're doing a floral design, in a sense. So we work from the sketch, and then we back off, everybody looks at it, decide whether it's completed. . . .

APERTURE: You've talked about fulfilling people's fantasies. I'm interested in the erotic qualities of your work. I'm interested in the relationship between food and happiness.

SW: Baking is a tactile thing. It's a wonderful feeling to mix with your hands, blend your egg whites and your ingredients. Even flower-making is tactile—you know when your petal is too thick because you can *feel* it in your hand. And working with dough is a sensual feeling. It's like a silk, it's like a satin. It's like a baby who sucks the edge of a blanket.

APERTURE: What else should I be asking you that I haven't?

SW: Our cakes are not inexpensive. I have to tell you that. We consider them works of art. We use the finest ingredients. They are what we call an affordable luxury. Don't forget, the whole wedding is a luxury. When else are you going to spend $50,000, $100,000, on a party? That cake is a once-in-a-lifetime item, and it really should measure up. It is not the time or the place to conserve money. Go for the great cake. The two most memorable things at these events are the cake and the dress.

SYLVIA WEINSTOCK

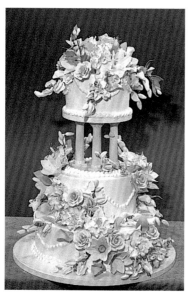 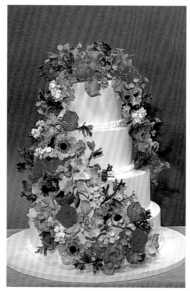 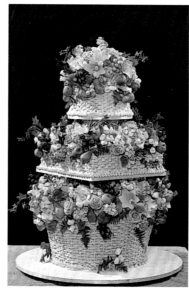 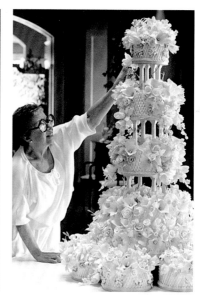

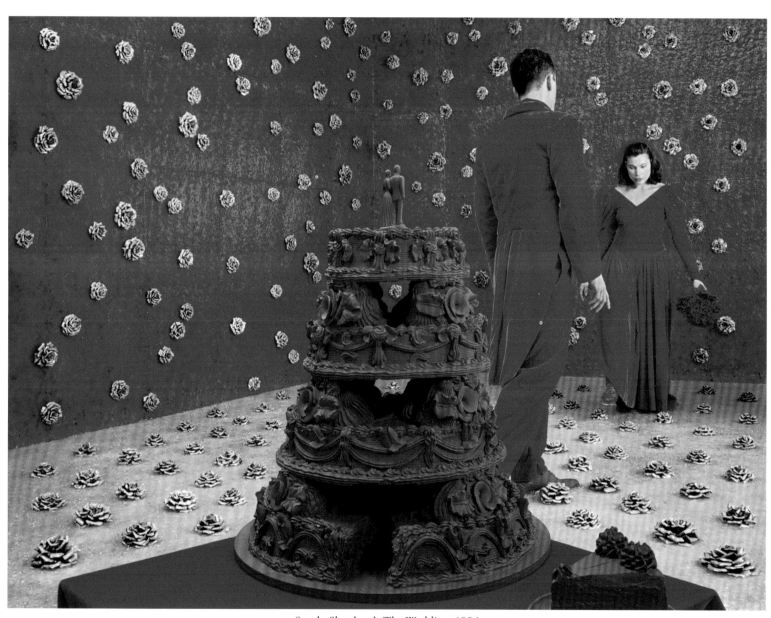

Sandy Skoglund, *The Wedding*, 1994

CALL THE ROLLER OF BIG CIGARS, THE MUSCULAR ONE,

AND BID HIM WHIP IN KITCHEN CUPS CONCUPISCENT CURDS.

LET THE WENCHES DAWDLE IN SUCH DRESS AS THEY ARE USED TO WEAR,

AND LET THE BOYS BRING FLOWERS IN LAST MONTH'S NEWSPAPERS.

LET BE BE FINALE OF SEEM.

THE ONLY EMPEROR IS THE EMPEROR OF ICE-CREAM....

WALLACE STEVENS, FROM "THE EMPEROR OF ICE-CREAM"

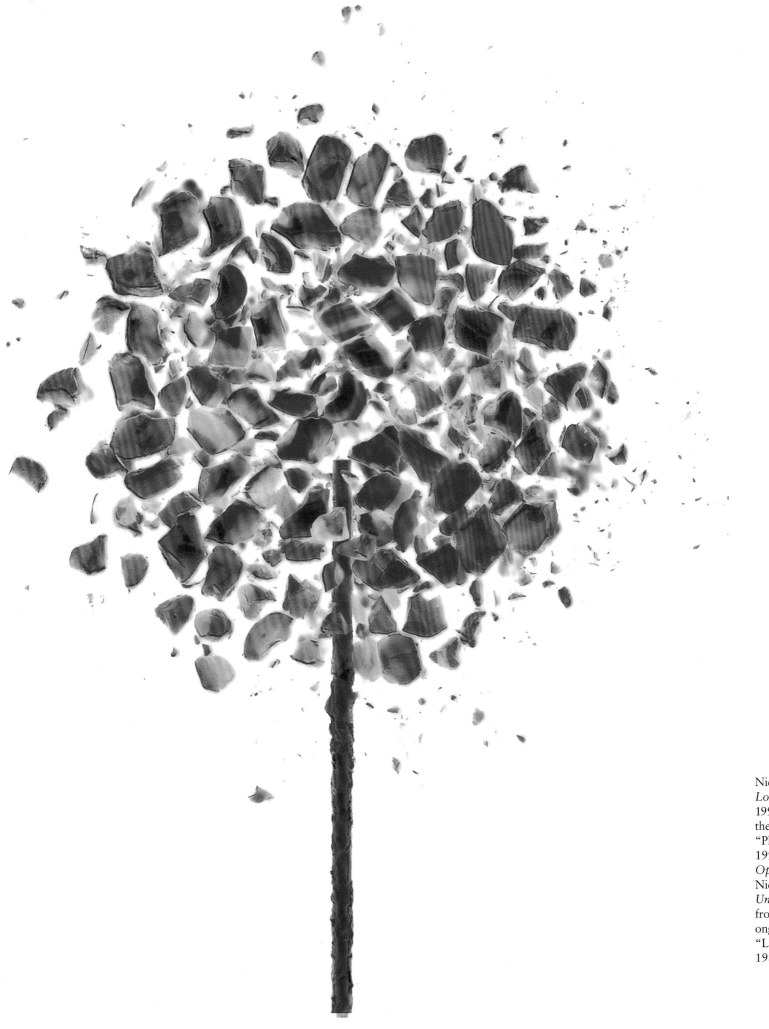

Nick Knight,
Lollipop,
1993, from
the series
"Plant Power"
1992–1993.
Opposite:
Nick Waplington,
Untitled, 1995,
from the
ongoing series
"Living Room,"
1986–present

AND SO TO FRUIT. A BIN OF CHINESE MANDARINS, A MOUND OF CHINESE GOOSEBERRIES, CIVIL SERVANTS TWO FOR A POUND. CABBAGE EARS, TURNIP'S HEADS. NUTCASES. SHREDDED SOCKS FOR MUESLI, SOUPS AND SALADS. SHREDDED MUSIC. WALTZING FROM BIN TO BIN, FILLING WHITE PLASTIC BAGS WITH THE BOUNTY OF THE EARTH, SHE WAS QUEEN OF ALL SHE SURVEYED. PROVIDING HUNGRY MOUTHS WITH SUSTENANCE WAS NO LONGER A PROBLEM. IT'S AS EASY AS PICKING YOUR NOSE, IN THIS HANSEL AND GRETEL HOUSE,

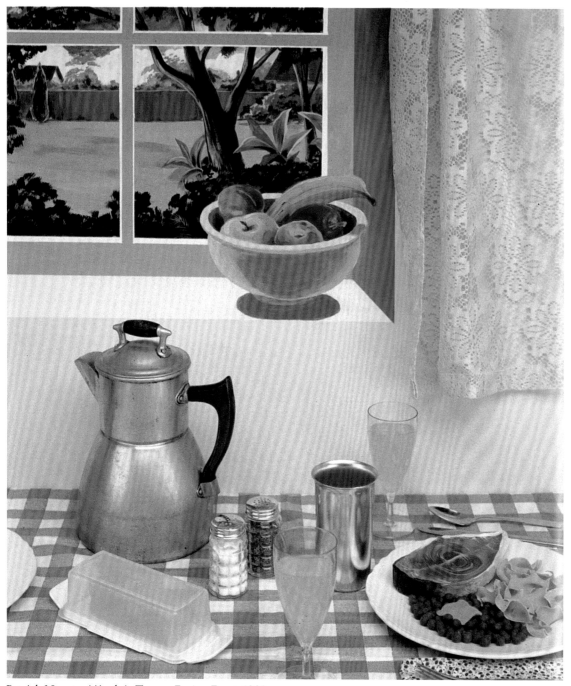

Patrick Nagatani/Andrée Tracey, *Fusion Feast*, 1989

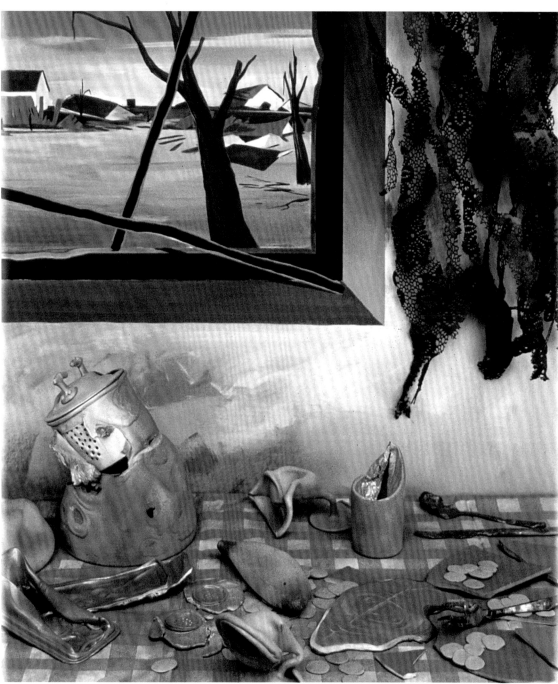

CANDY STONES, FEED THE MASSES. SO MUCH, SO MUCH, ALL OF IT DELIGHTFUL TO LOOK AT, MUCH OF IT PRE-COOKED, OR AT LEAST PREPARED, MUCH OF IT DEEP FROZEN, READY TO TRANSFER TO YOUR OWN FREEZER AT HOME. FREEZER. WHY HADN'T SHE THOUGHT OF THE FREEZER BEFORE, THIS MORNING? WHY HAD SHE IN HER PANIC FORGOTTEN THAT IN THE GARAGE WAS A FREEZER FILLED WITH THINGS WHICH COULD AT A PINCH BE COOKED AND EATEN? FUNNY HOW PANIC BLOCKED OUT PARTS OF THE MEMORY, KILLED OFF CERTAIN BITS OF THE BRAIN. DEEPFROZE THEM. MICROWAVED THEM. — EILÍS NÍ DHUIBHNE, FROM

EATING WOMEN IS NOT RECOMMENDED

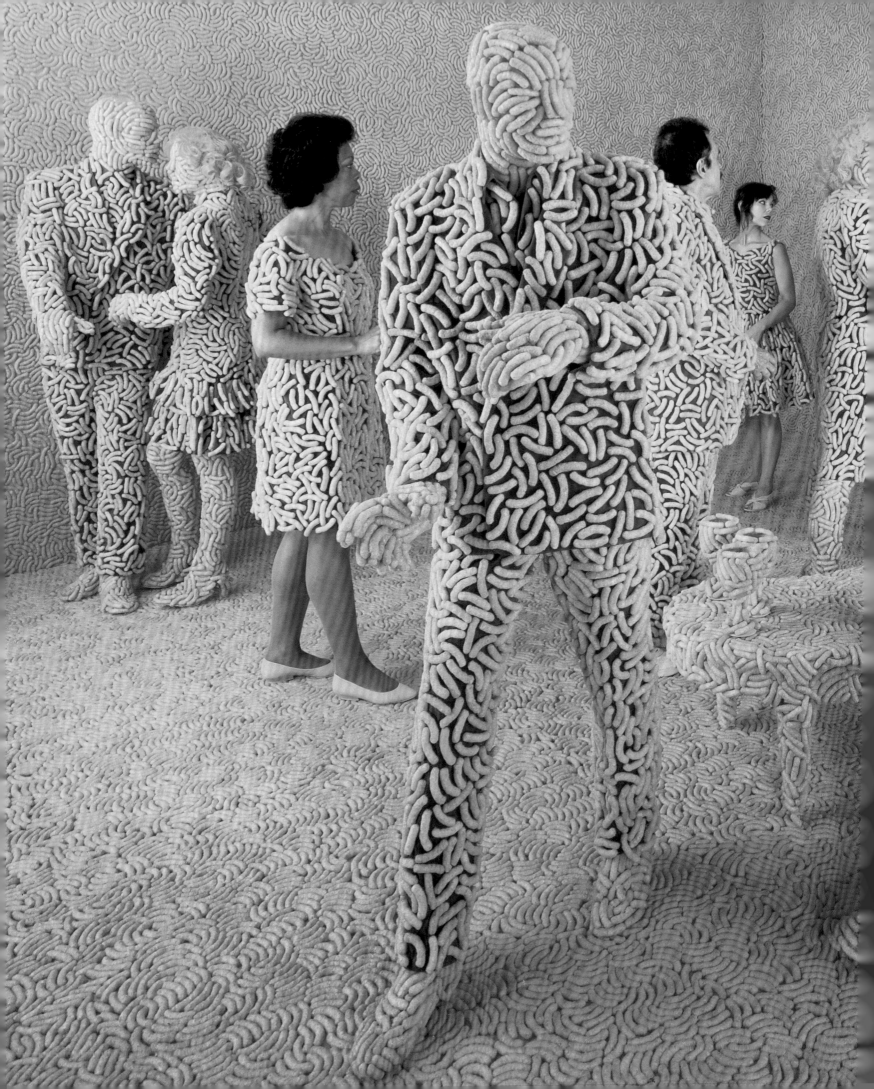

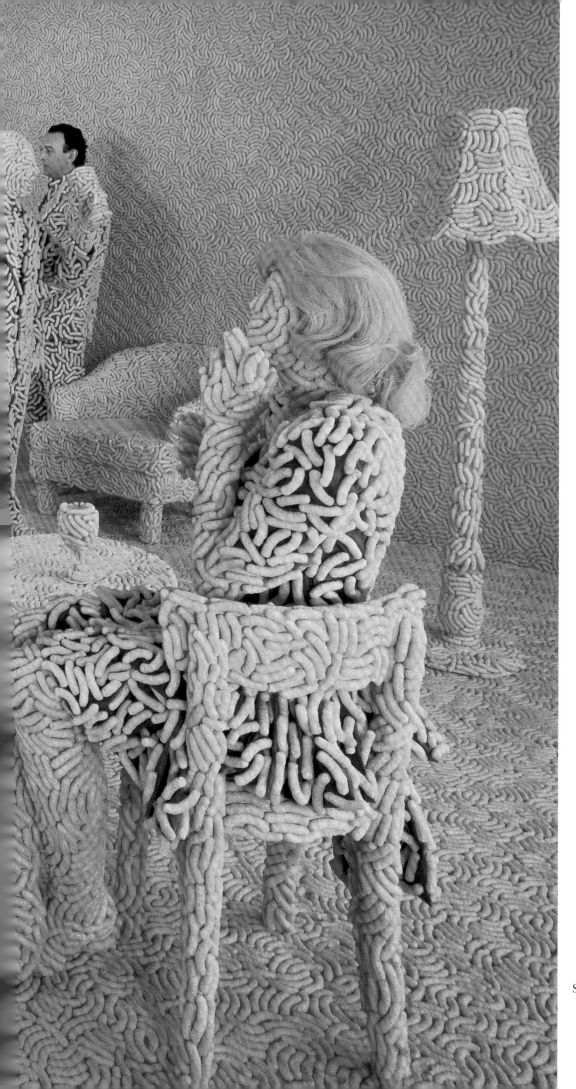

Sandy Skoglund, *The Cocktail Party*, 1992

As a child I loved the aroma of coffee. Smelling it drove me nuts cause it reminded me of cocoa, of chocolate, candy. Anyway, my parents rarely drunk coffee. But when they did, I'd stand at the kitchen table begging like a salivating dog for a lick. Momma and daddy would be sitting up, elbows on table, talking, sipping like white folks on t.v., shooing me away with, "Ya don't need no coffee, coffee'll make ya black."

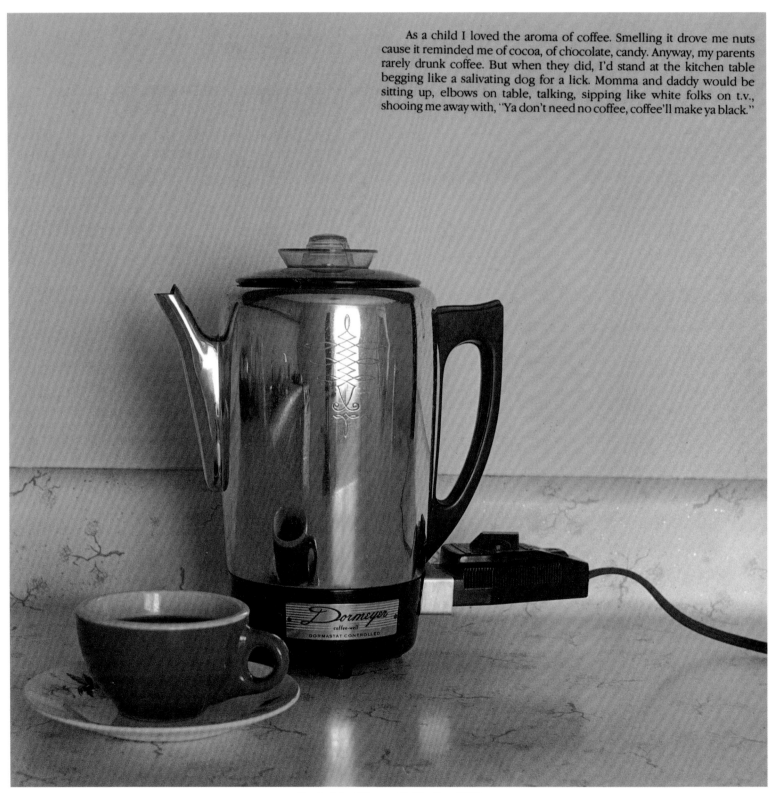

Carrie Mae Weems, *Coffee Pot*, 1988

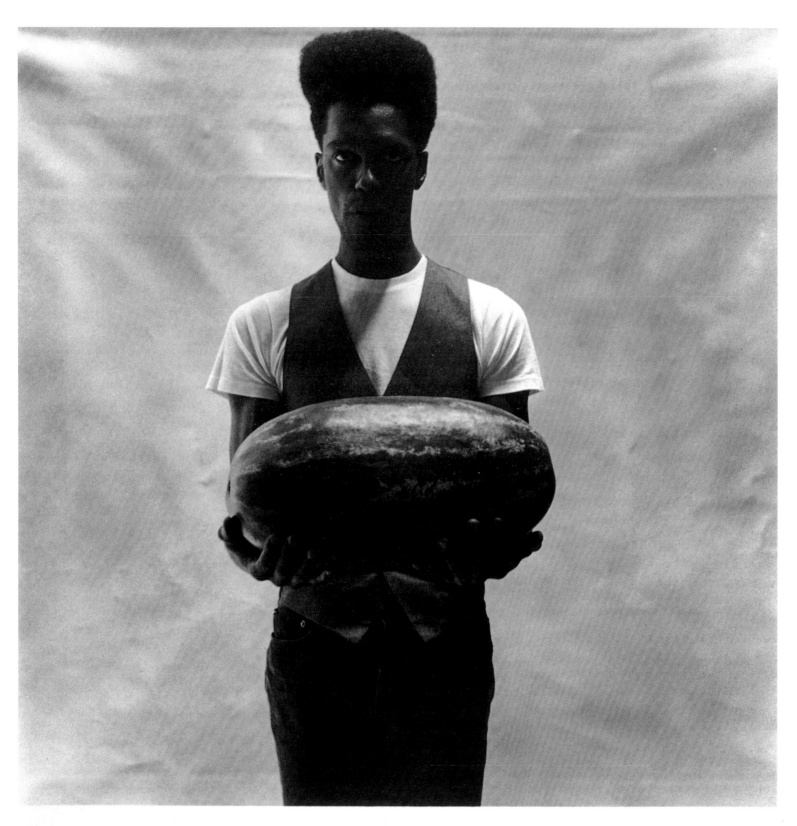

BLACK MAN WITH A WATERMELON

Carrie Mae Weems, *Black Man With A Watermelon*, 1987

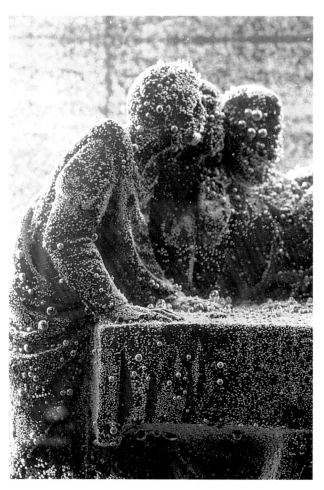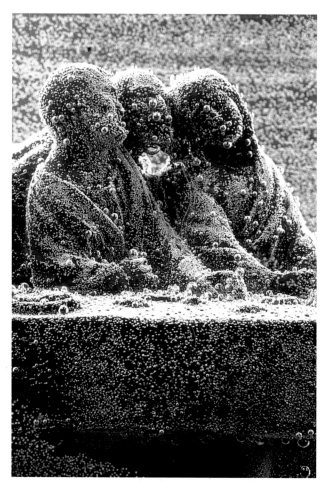

WHAT WOULD YC

WOLFGANG PUCK Whatever was in season. A good baked potato with some good caviar—that would be the best meal. And some good wine and champagne, of course. And Kim Basinger or Michelle Pfeiffer with them.

ROSE LEVY BERANBAUM Well, I'd probably lose my appetite. Because if I'm distressed, I'm not hungry. But if I weren't that kind of person, definitely beluga caviar, with my recipe for blini, which is perfect, and *crème fraiche*. And white truffle—I don't think I'd have it with pasta; I think I'd have it with risotto. Partridge, from France, that's been hunted, because partridge here has no flavor. Probably some unpasteurized milk. (Sometimes I've made ice cream with unpasteurized cream, and with the best vanilla from Tahiti.) But the thing is, for a question like that to be answered really well, I'd like a few days, or maybe a few weeks, or a few years. That way, every time they'd be about to behead me I'd say, "I haven't finished coming up with my perfect meal! You can't do it yet. Can't do it yet."

JEREMIAH TOWER As long as I wasn't in handcuffs, I'd rent a great vast cold room in Venice, on the canal. I'd have an enormous can of caviar and a bottle of champagne. I'd definitely have buckwheat blini with caviar. Black truffles. A wonderful game bird of some kind. A vast quantity of ice cream. And a hundred-

year-old Madeira, and then a glass of hundred-year-old Calvados. And at the end of it, just after dessert, I'd have hired five people to smoke Havanas about thirty feet away, so I could just smell them. Then they could take me away.

Actually, I'd like to be executed on the balcony and then thrown into the canal. Oh, God, those canals.

COPELAND MARKS Matzoh balls. No joke.
APERTURE I believe you. Are you of the feather-light, moderate, or extra-heavy school?
CM Feather-light. I don't do Eastern European food, although I can, but I wrote a book, *The Varied Kitchens of India,* and the Jews of Calcutta make *kooba*—and the *kooba* are matzoh balls. They're made with ground rice and stuffed with ground chicken and herbs. The Persians make matzoh balls out of chickpea flour—that's the Sephardic. So everybody makes their little matzoh balls.

ISMAIL MERCHANT Well, I would never be executed. [Laughs] I would execute people, but I would never be executed.
APERTURE What would you serve the people you'd execute?
IM I would serve them my *dal* before the execution.
APERTURE And that would guarantee them a place in Heaven.
IM That's right.

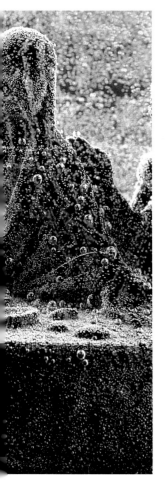
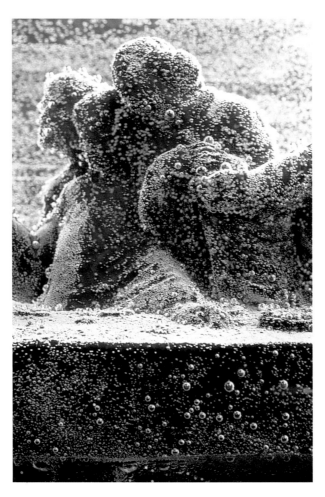
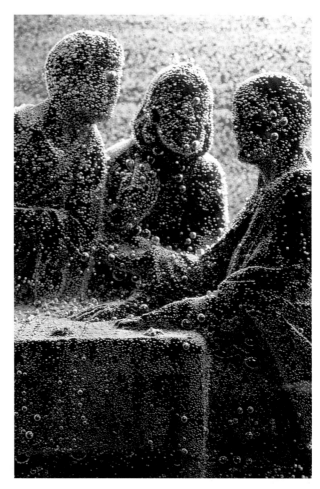

JR LAST MEAL BE?

RICK BAYLESS [Laughs] That's a hard one. You know what? Nobody's ever asked me this question before, so I've never really had a gut response to it. But it would probably be all desserts! [Laughs]
APERTURE And would you want to make it?
RB Yeah, I would. I really would. That would be fabulous. I can't think of anything that I would like to do more.

NANCY SILVERTON Mine would be a wedge of iceberg lettuce with Roquefort dressing, and a *rare,* rare, rare, rare, rare steak, and a hot fudge sundae for dessert. I'd be happy.
MARK PEEL Well, ice-cold oysters, with a little *champagne mignonette*, and then probably my new favorite thing, *risotto milanese,* with marrow. And then just a roast chicken with very dark, crisp skin—a roast chicken with garlic. And then a plate with ice-cold vanilla ice cream and sugar cookies for dessert. Actually, if peaches were in season, I'd have peaches.

MARCELLA HAZAN If I were about to be executed, my stomach would feel as hard as a nut and I wouldn't be able to eat anything. On the other hand, if on the eve of execution I were to be pardoned, I would order handmade tortellini served in a broth made by boiling beef, veal, and capon, meats which would then be part of my second course, a *bollito misto* that also included *cotechino* (pork sausage made largely from the snout), calf's head and tongue, served with four sauces, capers and parsley, fresh horseradish, red peppers and onions, and mustard fruits. I would ask for a salad of tiny green radicchio and arugola picked at dawn on one of the farm islands in the Venetian lagoon, tossed with olive oil from Lake Garda and vinegar made from Chianti wine. My dessert would be the dark chocolate ice cream made from the recipe in my book. I'd drink Jack Daniel's Gentleman Jack throughout.

JULIA CHILD Well, I'd like to be with some friends. I'd like caviar, *foie gras*, and oysters. And I love duck and fresh asparagus. And I'd probably have *potatoes Anna.* . . . And I'd be happy with a ripe pear and some green tea for dessert, or else some great chocolate. Or a delicious pie—peach, of course. And I would die happy.

BOBBY FLAY Caviar. That's it. Just caviar. I think it's the greatest food in the world. It's so good! I was just on a boat where they feature beluga caviar, like, whenever you want it. I just went through so much caviar. I love it. It's just such a different food. It has nothing to do with anything else. You don't cook it. You just open the can and eat it. It's amazing. And it's really expensive.

Andres Serrano, *Black Supper (I–V)*, 1990

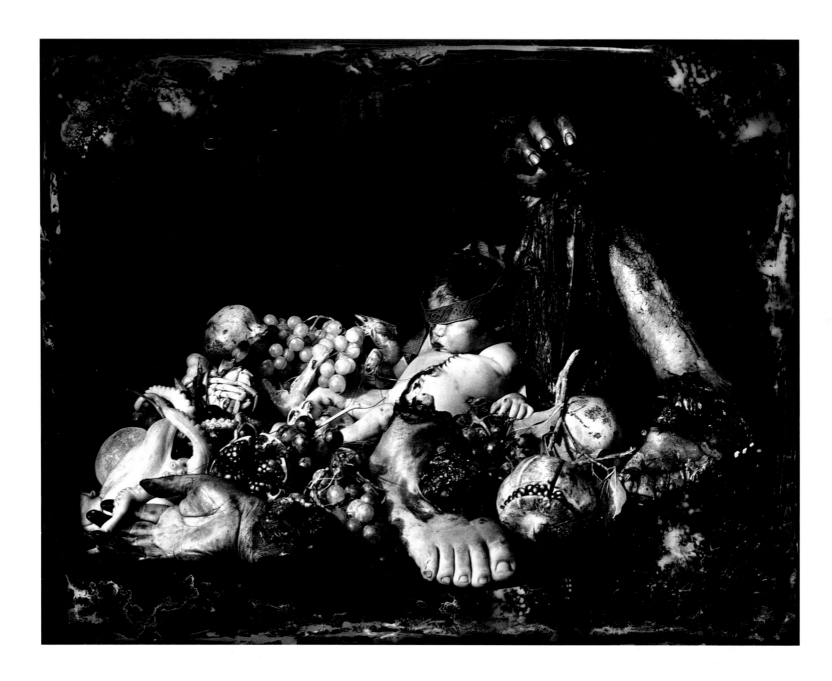

WHAT IS SO GHASTLY ABOUT EXPOSED INTESTINES? WHY, WHEN WE SEE THE INSIDES
OF A HUMAN BEING, DO WE HAVE TO COVER OUR EYES IN TERROR?
WHY ARE PEOPLE SO SHOCKED AT THE SIGHT OF BLOOD POURING OUT?
WHY ARE A MAN'S INTESTINES UGLY? IS IT NOT EXACTLY THE
SAME IN QUALITY AS THE BEAUTY OF YOUTHFUL,
GLOSSY SKIN? WHAT SORT OF A FACE WOULD TSURUKAWA MAKE IF I WERE TO SAY
THAT IT WAS FROM HIM THAT I HAD LEARNED THIS MANNER OF THINKING—A MANNER
OF THINKING THAT TRANSFORMED MY OWN UGLINESS INTO NOTHINGNESS? WHY DOES
THERE SEEM TO BE SOMETHING INHUMAN ABOUT REGARDING HUMAN BEINGS LIKE ROSES AND REFUSING TO
MAKE ANY DISTINCTION BETWEEN THE INSIDE OF THEIR BODIES AND THE OUTSIDE? IF ONLY HUMAN BEINGS
COULD REVERSE THEIR SPIRITS AND THEIR BODIES, COULD GRACEFULLY TURN THEM INSIDE OUT LIKE ROSE PETALS
AND EXPOSE THEM TO THE SPRING BREEZE AND TO THE SUN. . . . —YUKIO MISHIMA, FROM *THE TEMPLE OF THE GOLDEN PAVILION*

Above: David McDermott & Peter McGough, *Achievement of Sublime Through Renunciation of 1907*, 1989.
Opposite: Joel-Peter Witkin, *Feast of Fools*, Mexico City, 1990

JULIA CHILD

APERTURE: What's your favorite thing to eat, your favorite flavor, your favorite ingredient?

JULIA CHILD: I would say *among* my favorites, that's what I would say. Well, one of the most delicious things nowadays is a meltingly ripe Bartlett pear. I had one the other night—they're in season. When I think of all these "low-fat" manufactured desserts, and they're 200 to 300 calories, I just think of beautifully ripe pears, there you are, about ninety calories, and you couldn't have anything more delicious. And if you want to cook something with the pear, it's lovely to poach it in a sweetened wine syrup, served with a chocolate sauce. That's very good.

APERTURE: Are there foods that don't interest you to cook?

JC: Well, I went to a Chinese restaurant last night. We had a duck that had some kind of vegetable purée on it that was something like *poi*—you know *poi*. I don't find that very interesting. Maybe mixed with other things it's better, but it's not one of my great foods. It's just bland and mushy. Of course, mashed potatoes are—

APERTURE: Pretty great.

JC: But there was something about the quality of this mush that I didn't care for. I'm also not fond of Tex-Mex food, with all that hot, burning effect, which to me kills the taste buds. I don't think that kind of food goes with good wine. But then, that's not the kind of food I eat.

What makes a great meal is, of course, beautiful cooking, very fresh ingredients, and a good balance. If you're going to have a rich dessert with a lot of cream and chocolate, you want to build up to that with things that aren't too rich. To start out, say, with sea scallops in a creamy sauce, and follow that with a rich duck dish and *potatoes Anna,* and then end up with this rich dessert, that would be very poor planning, both nutritionally and gastronomically. If you have a terribly rich main course, cook something light for dessert like a fresh pear, or figs poached in wine. Also, I like both the French and the Italian method of not having a big plate piled with food; that's for people who are feeding rather than dining. You find a lot of restaurants piling the plates high, and you end up not knowing what you're eating.

APERTURE: You've done a great deal to preserve and clarify traditional cuisine, but some of your more inventive dishes—the spaghetti Marco Polo—go beyond any traditional aesthetic. When you're incorporating nontraditional tastes, flavors, and textures, how do you know when a recipe is complete?

JC: I think that's part of your training. I was with Jacques Pepin last night, and we were talking about this long experience of having done it and how you instinctively know what goes with what.

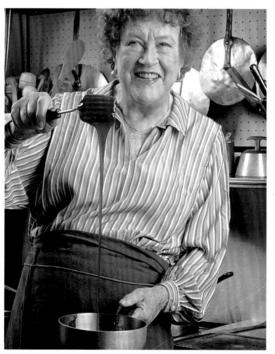

I mean, if you're going to be a professional cook, it's a good ten years of training. And the more you cook, if you run into a problem you sort of go back to your history and you say, "Well, that worked," and so forth. So I think your experience and your mental computer help a great deal. And when you begin, you really have to learn how to eat, particularly if you come from a family serving nothing but pizzas and hamburgers. I think you're very lucky if you grow up in a family that loves food, because then you develop your taste for food early on.

APERTURE: I guess many people think of you as a French chef.

JC: You can have that title! I'm not a chef, I'm a home cook. You're not a chef unless you're running a kitchen.

With the life-style we have now, and people's fear of food—they're not really enjoying it—my type of cooking is probably going to be for the hobbyists, the people who just love to cook, the way they might like to build a boat or paint a painting. I think it's probably going to go into the hobby class.

APERTURE: Do you like people to watch you cook, and do you like to watch people eat the food you've made?

JC: I do indeed. One reason we bought our house is that it has a great big kitchen, kind of a kitchen/living room. This is an old home; if I were building a new one, I would actually have a kitchen/living room. I'd much rather cook right there in my kitchen/living room, and I'm very happy to have someone, anyone, help.

APERTURE: Is there any food you find particularly challenging?

JC: I think one of the most difficult things to do is to cook breakfast, and get the toast so that it doesn't burn, and not let it get cool before the eggs are done, things like that. I think that's very difficult. If you can assign someone to each task, then it won't be so difficult.

APERTURE: It sounds like a great idea—help for breakfast.

JC: Who eats the burned toast?

APERTURE: Do you have any essential food rules?

JC: Food should be the freshest and finest always. And, plan what you're doing. Even if you just have three minutes before you start in, have a plan so you don't have to take longer to cook, and you get started at the right time. A list is very important, because very often you've forgotten the potatoes, or you forgot to turn the water on for the peas, or something like that.

The key is to know what you're doing and to enjoy it, and to just have fun with the creation of a meal. Enjoyment of the mechanics of cooking is very helpful, and if you've had enough training and experience you can enjoy them. Take some lessons, or go to cooking school or something, or cook with a friend, so that you know the mechanics, and you'll have a really good time.

APERTURE: Do you have any secret cravings, foods you just go back for time and time again?

JC: Well, I love bacon. I always eat it on Sundays.

COPELAND MARKS: My favorite food is the one I'm working on at the moment. When I was writing the Indonesian cookbooks, I thought there was no cuisine in the world that interested me more, and that was more delicious. And besides, I was writing it in the countries of origin, which I always do, so that I connect the ambiance of the country with the flavors I'm enjoying.

APERTURE: Is there a food you find the most interesting to cook with?

CM: That's a difficult question, because my tastes are eclectic. I can and frequently do cook unconventional things. I don't mean dog or cat or rubbish like that. But I like to be challenged.

APERTURE: How does cooking a culture's food in its environment compare with cooking it elsewhere?

CM: I was in a remote corner of the island of Sulawesi, which is now called Celebes, and there was a family that lived on the beach, in a little ramshackle hut of palm leaves and all. Otherwise I was there alone. One of them knew a little bit of English, so I said, "What's your best dish here?" And they said, "Barbecued smoked chicken, and then we cook it in coconut milk where we grate the coconut and reduce the milk"—not coconut milk out of cans, as I do here, somewhat cheating. And there it was, over a wood-and-coconut-husk fire, smoking all over the place, and wide open, because we were on an empty beach. (I like to swim.) It was marvelous.

About four months later I made it in New York. How? I couldn't burn my furniture, so I stuck the chicken under my oven broiler, but I used a little trick: since my father was English, I drink tea in the morning, so I sprinkled tea leaves on the tin foil. And as this was broiling and the tea leaves were burning, and somehow my smoke alarm didn't go off, it smoked the chicken! Then I put it in the coconut milk with *galangal,* sliced shallot, lots of ginger, a heaping teaspoon of red-hot dry chili flakes, salt, and about a quarter teaspoon of turmeric. And I cooked it slowly. That's the name of the game—slow cooking. It was excellent. I'm not saying it was better or worse. It was excellent.

APERTURE: That provokes related questions for someone who focuses on the cuisines of other cultures. First, how do you know when your dish is right? How do you know when it's done? And second, are there flavors, or utensils, that you've borrowed from the cuisines you've studied, and that you think have cross-cultural value?

CM: You're doing the difficult thing of transferring a cuisine, and one of an uncommon ethnic type. You're not going to find the dish in a restaurant. So you must have a memory for flavors, and you must have a good nose. Both of which I think I

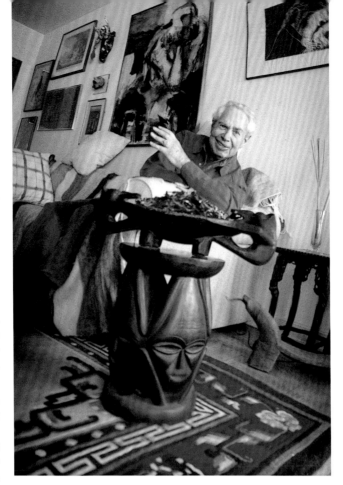

do. I remember flavors, and I say, "Now, it was sweeter than that; I'll put in a little more brown sugar." (I'm thinking of a Moroccan lamb dish with a lot of sugar and dried fruit, prunes and apricots and so on.) The recipes in my books are usually new discoveries for the most part. So I have to rely on my nose and tongue.

As for tools, I like a mortar and pestle. In Malaysia they like to take onion, ginger, and garlic, and grind it in a mortar and pestle. They don't put it in their Cuisinart; they don't have one. So, a mortar and pestle, and a wok. Those are two things I use frequently.

APERTURE: Your recipes seem carefully researched and authentic.

CM: Authenticity is my hangup. You can't pass judgment, and you must not. You should not modify the recipe. In some recipes, for example, they put a lot of hot chilis.

I say, "All right, eight large cloves of garlic, and twelve red-hot fresh red or green chilis." Fine. Then, in a note underneath the recipe, I say, "This was too hot for me, but it's the real thing, and that's why I have included it."

APERTURE: Is there a conflict in creating a restaurant cuisine out of a home-cooking cuisine?

CM: All these cuisines started out as home cooking. They do have to be translated into restaurant terms, but I don't see a clash; it's just a progression from home to restaurant cooking.

APERTURE: So do you see yourself as an anthropologist of food, or perhaps a food historian, as much as a chef?

CM: I've been called everything. I started out as a cook and chef, going from cook to chef after a considerable amount of experience and training, but informal training. Then I began to add the people of the country, some of their recipes and comments, to my work. So I became an anthropologist, I guess. Then I'm also a food historian, because the ethnic recipes of the world are disappearing. They are endangered species. I'm recording the history before they disappear.

APERTURE: So documentation is just as important for you, in fact more important perhaps, than actually creating?

CM: No, I wouldn't say that. I'm not creating food; I'm recording it. The food has been created by these peoples in these countries that I've cooked in.

APERTURE: Do you have any essential food rules?

CM: Fresh food. Second, follow the authentic recipes. If you must modify it, modify it as too much salt, too little salt—simple things rather than drastic things. And finally it must be tasty.

APERTURE: Now, no matter where you are in the world, what must you have in order to cook?

CM: My brain. I have to be able to remember.

COPELAND MARKS

Michael Spano, *Fruit Cup*, 1989

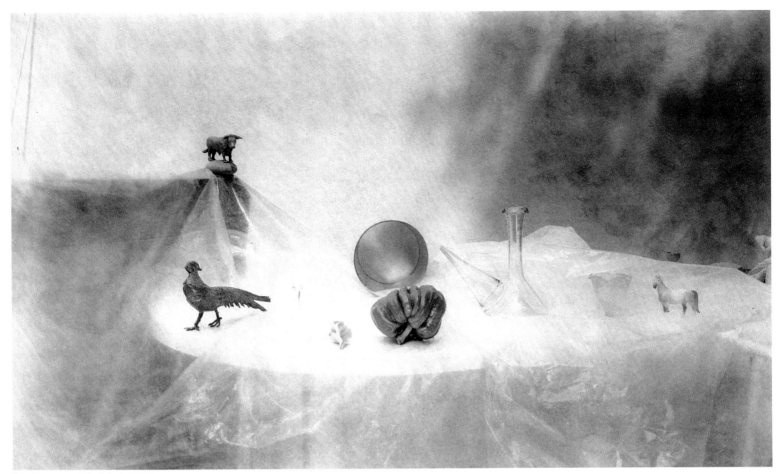

Jan Groover, *Untitled*, 1992

Jan Groover, *Untitled*, 1992

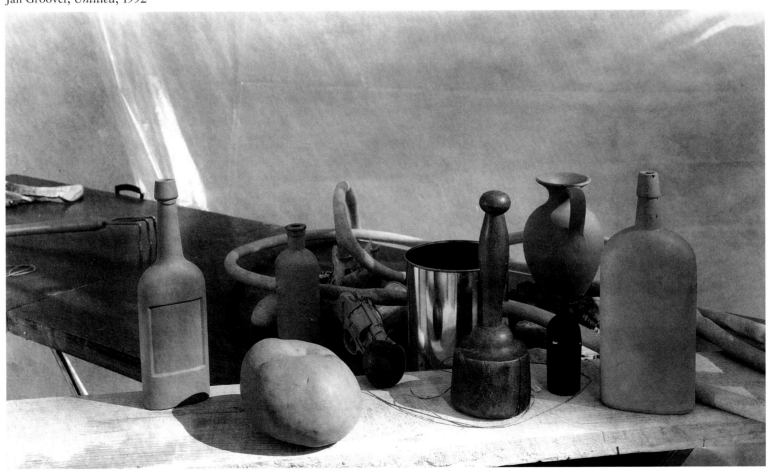

APERTURE: What's your favorite food, your favorite flavor?

JEREMIAH TOWER: It changes. Since it's cold and damp today, one of my favorite things would be a black-truffle hamburger. That and a great, bold Burgundy would send you to heaven. A shellfish essence mounted with wonderful Normandy butter is clean, pure, rich, and just an inspiration. Also the flavors of very fresh, simply prepared vegetables, like fava beans—fava bean purée served in an artichoke butter.

Pure flavors are extraordinarily complex. Flavors only become one-dimensional when they get mixed up. When you're a child with a paint box, and you discover red and blue and all those colors, you think, "Well, if they're this marvelous by themselves, they must be wonderful together." But mix them all up and you get brown or mush—something muddy.

APERTURE: What's the difference between a muddy flavor and a pure one?

JT: With a muddy flavor, everything stays on the same note, or slightly different notes all at once, without any structure — just noise. A clear flavor is like a single note from an oboe. An incredible clarity.

APERTURE: So you're looking for reduction and purity.

JT: Yes, but not the purity of minimalism. It can be the clarity of Baroque furniture. The clarity of a great big kilo tin of caviar! It's like, "Here I am!"

APERTURE: Are there cooking techniques you like or dislike?

JT: Techniques haven't changed much, if at all. The last book that really changed anything was Escoffier's *Guide Culinaire* of 1906. I would tell cooks to read the chapter introductions. I'm not saying you have to make the dishes—some of those are not for our time, although plenty of them are.

APERTURE: What does it mean to say a dish isn't for our time?

JT: People today wouldn't enjoy a turn-of-the-century menu. Escoffier inherited lots of highly constructed dishes that we should get away from, because they're really just intellectual. They sacrifice the quality of the food in order to pile something on top of something, on top of something else, and it gets handled so many times it gets cold. You have this intellectual, architectural idea, and you have to sort of fake it.

Ironically, a lot of chefs today are doing exactly that: they take eighteen snow peas and arrange them in a fan, and then you put something at their ends, and you have fourteen drops of five different herb or chili oils at the end of each pea.

APERTURE: So you see the excesses of the turn of the century as a kind of parallel to the minimalism of today? A gastronomic sadism.

JEREMIAH TOWER

JT: Yes. It's intellectual—it's chefs thinking too much.

APERTURE: You've mentioned Western and American tradition. What about other cultures?

JT: I'm an American raider like the rest of us—the world is ours to grab at! I'm ruthless about taking from other cuisines. And now the marketplace has just exploded internationally. Five years ago the airlines figured out how to ship food.

APERTURE: Is there any food you find particularly challenging?

JT: Of course the most difficult thing to produce in a restaurant is toast. And I rail on about toast, whether it's being used by itself or for a canapé or hors d'oeuvre. If you bite into it and the whole thing shatters, food goes flying down your clothes.

APERTURE: You're revealing your past life a bit here, because you're talking about toast as an armature. You're thinking: does it hold something up? You trained and practiced as an architect; does that inform your cooking?

JT: Architecture helps me in terms of organization and discipline, certainly, but it's also there in the way I think about food. I'm always talking about layering, building a sauce, constructing. There are influences there, not in terms of building on the plate but before the food gets to the plate.

APERTURE: We also have to call you an artist; but what kind besides an architect?

JT: Maybe it's like being a sculptor: you get wet, you get dirty, you carve up food and then you throw it in the fire.

APERTURE: Sculptors always have an issue: when do you stop?

JT: That, of course, is what we've been talking about throughout this conversation. When you start screwing up the ingredients you've gone too far.

When I was a teenager, I read that book on Michelangelo by Irving Stone, *The Agony and the Ecstasy*. I've seen Michelangelo's so-called "unfinished" sculptures, which I'm sure are quite finished, with the figures emerging from the marble. And yes, there is a moment to stop, and boy, that's exactly when you've either made something wonderful or screwed it up.

APERTURE: Then what about the relationship between you making food and other people eating it?

JT: There are moments when I look across a restaurant dining room, and I see a hundred people all eating—and it's the most bizarre sight! All these forks being shoved into mouths—it's like an out-of-body experience. Think how intimate the act of eating in front of somebody else is.

APERTURE: What must you have in order to cook?

JT: A bottle of cold white wine for the cook! Actually, just a handful of fresh ingredients is all I need.

APERTURE: Are there ingredients you're constantly thinking about?

DANIEL BOULUD: I love tomato very, very much. You can do all kinds of things with it, and always have a refreshing and light approach.

APERTURE: Is texture important to you?

DB: I don't like too many textures in a dish, but a dish may require them. I do a steak of tuna peppered on all sides, and served with a purée of parsnip. There's a shallot confit that adds a little texture—a confit in port and red wine, so it has a sweet-and-sour taste. And the purée is a bit sweet also, or fragrant with the parsnip, and it has a little cream in it, so it has a silky texture. And the tuna has the crusted pepper around, a little crunchy. All this together is wonderful.

APERTURE: Your renowned dishes have these contrasts.

DB: They layer. For example, I do a crabmeat salad, and the crab is seasoned with lime, olive oil, coriander, and mint, and on top there's a little diced cucumber and

DANIEL BOULUD

mango, and crushed peanuts, and there's decoration with a small dice of cucumber and mango and a coulis of mango and oil of mint. The cucumber is crunchy and refreshing. The mango has a melting touch, exotic, soft. And when you eat the crab you taste maybe the mint, and then in another taste maybe the coriander, and then maybe the peanuts—these layers of flavor.

APERTURE: What else goes into your meal? Wine, of course.

DB: Always good bread. And company. The food and the wine are the two main issues, definitely. We have a lot of wine amateurs in this restaurant who go for the big wines, the vintage wines. So we try to have food that can match that high-quality wine, flavors that are hearty, natural, and not overpowered by too much herbs or spice. You have to be careful; sometimes a seasoning can be overpowering. Except truffles. Of white truffles you can never have too much!

APERTURE: What's the dialogue with your patrons?

DB: I like to watch people eat my food. Sometimes I say, "I love that dish, and I'm giving it to someone who has no clue what I was trying to do with it." But I don't know how they think.

APERTURE: When you cook at home, is your family an audience the way your patrons are? Who is tougher?

DB: I have a daughter, who has just turned six, and she isn't difficult about food; she just doesn't like many things. If you give her what she likes, she isn't difficult at all! But the patron is different. In business there's a reality, which is to stay in business. You make sure the customer comes back. Cooking for the family is relaxation and pleasure, but cooking for a business is a challenge every day. However, today the pleasure of running a restaurant is maybe better than before, because we can sometimes cut out the middle people. We go directly to the source for many things. We buy lamb in Pennsylvania directly from the farmer.

APERTURE: So that's more like the past, in a way.

DB: Well, in the old days we couldn't conserve things so long. Now you can taste an apple in August and it's an apple from the year before. And it's terrible. Things were definitely much tastier when they were only available in season. But on the other hand, farmers today really understand how beautiful their products

are. Before, they didn't have the support from chefs to make things grow better.

APERTURE: Do you have a favorite utensil? Or is there a new utensil that you now can't live without?

DB: I think my favorite utensil is a good wooden spoon, because you can do anything with it. A new utensil we have in pastry now is the *silpat*, which is a sort of rubber-based mat, and whatever you put on it will never stick; so you can make things very thin, and it works. It has replaced baking paper. It has replaced Teflon. It has replaced everything. It's so wonderful it's unbelievable.

APERTURE: Are you a visual artist or a performing artist?

DB: We are performing artists. The food is visual when it comes to the front, but more emotional when it's still in the kitchen. I have a lot of young cooks trying to be good cooks for me, and they also perform. We can get them to be better, and that's a great pleasure. I love what we do, and I love this business. But it's a very tough business. There's always a financial worry. And if I have eighty-five employees, that means I have eighty-five kids.

APERTURE: Can you talk about the relationship between food and sex? What are the erotic qualities of food?

DB: It depends on the way it's eaten, I guess! The texture of food can be erotic to some people—if it's crunchy and juicy at the same time and all that. Food is very exciting. But I don't find it erotic too much. Maybe if you are with a lover at home, and there's a lot of love and passion between the meal, that becomes erotic, to cook and eat together. But in my restaurant I just picture it oddly to be erotic! [Laughter]

APERTURE: Do you think some foods are aphrodisiacs?

DB: To me, white truffle is a very strong aphrodisiac; the aroma. Spices too—hot spices. But erotic?

APERTURE: What's in your refrigerator at home?

DB: Blood oranges for breakfast. We have cheese sticks for my daughter. We always have fresh vegetables to make soup. Always some ham. Champagne, of course.

APERTURE: What must you have in order to cook?

DB: What must I have? I must have flame. After that I manage. As long as I get a flame, I'll figure out what I'm doing.

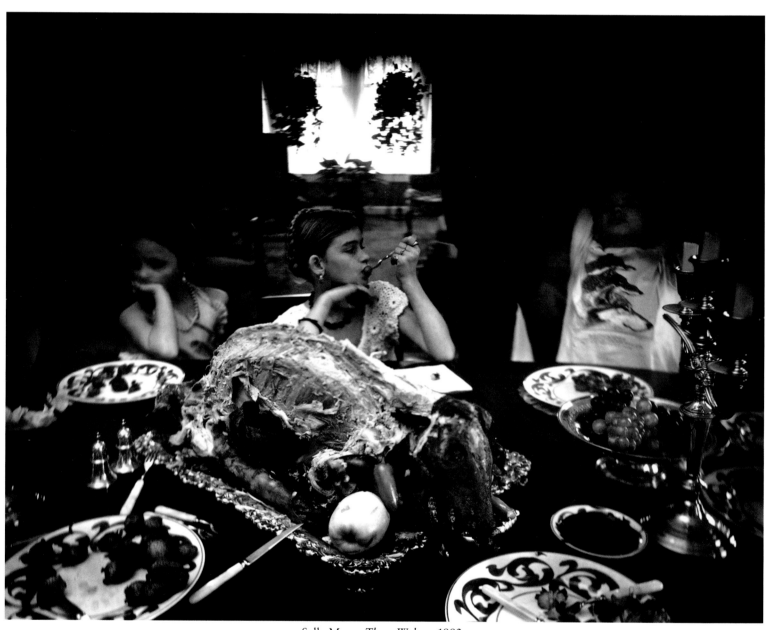

Sally Mann, *Three Wolves*, 1992

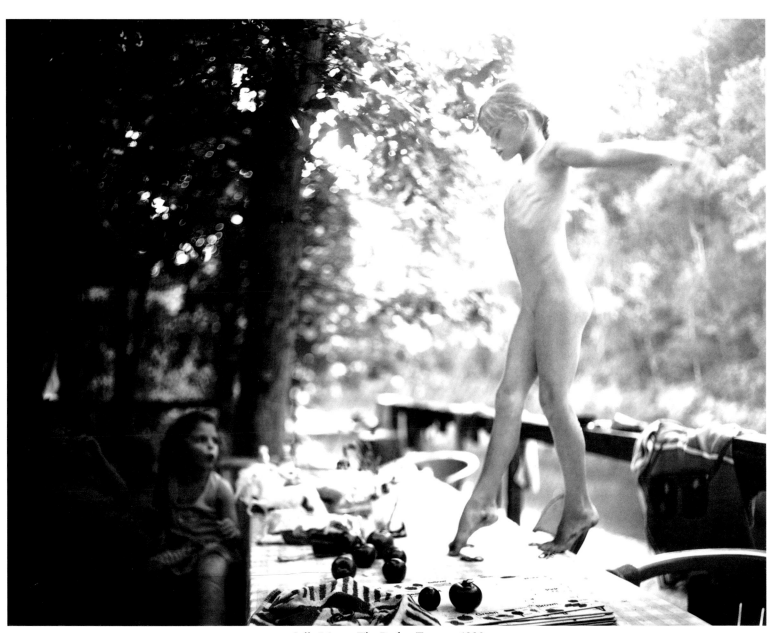

Sally Mann, *The Perfect Tomato*, 1990

ISMAIL MERCHANT

APERTURE: So tell me what your favorite food is, and your favorite flavor, and your favorite ingredients.

ISMAIL MERCHANT: Mustard is, of course, my favorite thing, with mustard seeds. And ginger, garlic, and green chilis are my favorite spices. Cumin also.

APERTURE: What foods don't you like?

IM: I never liked pork. Otherwise I eat everything, including tripe. Tripe with Indian lentils is one of my favorite foods. I love kidneys and liver and brains and tongue. There are people who are scared of these innards of animals. I just love them. Because this is how I was brought up, you know; at home in India we ate everything, including the trotters. Trotters were made in the most delicious manner at home, again with little split peas, and blended with the most delicate spices.

APERTURE: Did you cook when you were growing up?

IM: I was always sort of presented with cooked meals, so I never had the opportunity of making anything until the age of nineteen, when I came to America.

APERTURE: You're a film producer, and food plays an important role in many of your films. Your films also seem to play a role in your writings about food.

IM: The one is interlinked with the other. Producing a film, you want to make it with passion and love. Similarly with cooking: you cook with passion and love. So it's all very much intertwined.

APERTURE: If we talk about you as an artist of food, do you think you're a visual artist or a performing artist?

IM: You can't be one without the other. You have to have the visual flair as well as the ability to perform. When you present a meal, you garnish it with a little fresh coriander on top, or some parsley, or some wonderful shapes like eggs and things—you decorate your meal so it becomes a visual treat as well as fulfilling your palate.

APERTURE: Do you like eating in restaurants? I've never thought Indian food a restaurant cuisine.

IM: I don't like to go to a lot of restaurants—they're an easy way out. Climbing a mountain is much more healthy, more invigorating, more challenging, than getting on a plane, and climbing a mountain is what you do when you cook at home.

APERTURE: You've created a cuisine that has Indian cooking as its basis, and complex relationships of spices and ingredients, but that incorporates experiences you've had in the West. Do you think that there are languages of food that respect cultural borders, or is food universal? Can you make a new culture of food from different cultures?

IM: You can always create a new culture from different foods. The language of food is not contained in India, or in France. The language of food is universal, because hunger is universal. Whoever you are, the needs are the same: to satisfy your tummy, your senses, yourself. And to share that with your friends and colleagues. Of course food is created by each country: whether it's spicy or less spicy, or subtle, or has sauces and things, is ingrained in particular cultures. But as my art, cinema, has no barriers, food has no barriers.

APERTURE: How does the process work? You're inspired by the ingredient?

IM: You are inspired by your own needs that particular evening.

APERTURE: How important is texture to you in food?

IM: Texture is not that important. Taste is more important.

APERTURE: What about color?

IM: Color, yes. You have to have color in your food. It should look appetizing. Saffron is wonderful, and turmeric, and the blends of spices, and their smell. All that gets you high, you see.

APERTURE: Do you have any secret cravings, some food you just want at all hours of the night?

IM: *Dal.* Not at all hours of the night, obviously. But if it's good *dal.* . . . There are about two hundred varieties of *dal.* I would be happy just to have *dal*, because that really is the most delicious and satisfying thing.

APERTURE: Do you have any food rules?

IM: The basic rule is just jump into it. Don't be afraid or shy. Then don't labor over it. Laboring is not a good idea. I think those are the two main rules. And then, of course, enjoy it!

My thinking in life is that one cannot be afraid about doing anything, and particularly cooking. The minute you think, "Oh my God, how is it going to turn out?" that's the death of a thing. The challenge is that you are creating, with excitement, something you will share with so many people, that will surprise so many people, and you'll get accolades at the end of the meal, and people will lick their fingers and say "Wa-wa"—that is for great praise.

APERTURE: What's your favorite food, or what ingredient do you like to work with best?

WOLFGANG PUCK: There are too many to mention. Different seasons have different favorites: the first strawberries, or the first cherries in the summer; the first white truffles from Italy, in October. Peaches off the tree. If you pick a really ripe raspberry, it will be very different from what you find in a supermarket. Every season has different surprises. One thing always: I love food when it is of the best quality. In the summer, wonderful fruits, peaches, plums. Or a great tomato salad with some fresh basil and vinegar—it will be very simple but very good. In the fall, mushroom, game. In America we try to give the public everything all year round, but not everything is good all year round.

I also love well-prepared food, as long as the preparation doesn't get the better of it.

APERTURE: Do you have a favorite food-preparation activity?

WP: I love to go to the market. If I see a wonderful Dungeness crab, I'll buy it and cook it, maybe in the Chinese style. In Tokyo I love to go to the fish market. Or, in the South of France, to a regular farmer's market.

APERTURE: Your mother was a good cook?

WP: Certain things I remember from when I was young. My favorite always was scallopini of pork, breaded and fried.

APERTURE: Do you like cooking for yourself?

WP: I don't cook often at home. I spend my life in the restaurant, so at home I don't really eat. I have a very good espresso machine for a good cup of cappuccino in the morning. That's really important to me. And toast with apricot marmalade like my mother used to make, where you can really taste the fresh fruit and not the sugar. Or blackberry or raspberry marmalade with some good bread that we make ourselves, walnut bread—that's perfect for me. I'm not going to wake up and cook ham and eggs.

APERTURE: Do you like to watch people eat your food?

WP: Absolutely. I like to see what people do, I like seeing them appreciate it. A lot of people really concentrate when they eat, and you can see the expression when they really like it.

APERTURE: Food and sex: are they related? What are the erotic qualities of food?

WP: The enjoyment of food and wine is a very sensual experience. But I don't think it's like sex. It's like making love: you can eat just because you're hungry, and then you're full. You can eat something that's not healthy, not good-looking, not great-tasting. Or you can really take the time.

APERTURE: Can you talk about the process of making food from different cultures?

WP: I lived in Austria, that was one culture. I lived in France, that was one culture—they use a lot of different herbs and spices, but essentially it's one cuisine. But in California you have so many cultures that mix together but also have their own identity. That inspires my cooking. My cooking should represent my city, the place we live, in the ingredients but also in the culture. Chinese-style duck, tuna sashimi, risotto with white truffles—to mix all these different cultures together on one menu might not make much sense in France, but in Los Angeles it makes a lot of sense. Chinatown, Koreatown, Little Saigon. If an American artist went to China and painted there, he would do something completely different from a Chinese painter.

APERTURE: If you and your great chef colleagues are artists, are you visual or performing artists?

WP: I think cooking has to please more than just one of the senses. Obviously the first thing it has to please is the eye. I don't want to make it so complicated. An architect draws lines, and everything has to be precise; I'm more like a painter. But then the smell is also important: if you buy food that's really fresh, it's going to smell good, even before you cook it.

APERTURE: What are your essential food rules?

WP: Buy the best product and don't screw it up. That means you have to know about the product, and how to prepare it.

APERTURE: What things do you think affect a meal other than the food?

WP: The environment is very important—the ambience, the place where you're enjoying the food, the people you're with. We had a big empty wall at Postrio, so I asked Robert Rauschenberg to paint a twenty-two-foot-long painting. Before it was up, I used to stare at the wall like a blank, it didn't inspire me. As soon as the painting was up I felt completely different. The same at Spago: without the flowers, it would seem empty. The flowers give it happiness, and fun.

APERTURE: Do you have secret food cravings—pickle-and-peanut-butter sandwiches? McDonalds? Hot chocolate?

WP: For junk food and stuff like that? Not really. I can't stand the smell of most junk food. I don't wake up in the middle of the night and say I want this or that. I never was pregnant, maybe that's why! I just eat at the restaurant, and I eat everything, grazing all day, tasting everything from the sorbet to the salad to the meat. My day is a meal.

WOLFGANG PUCK

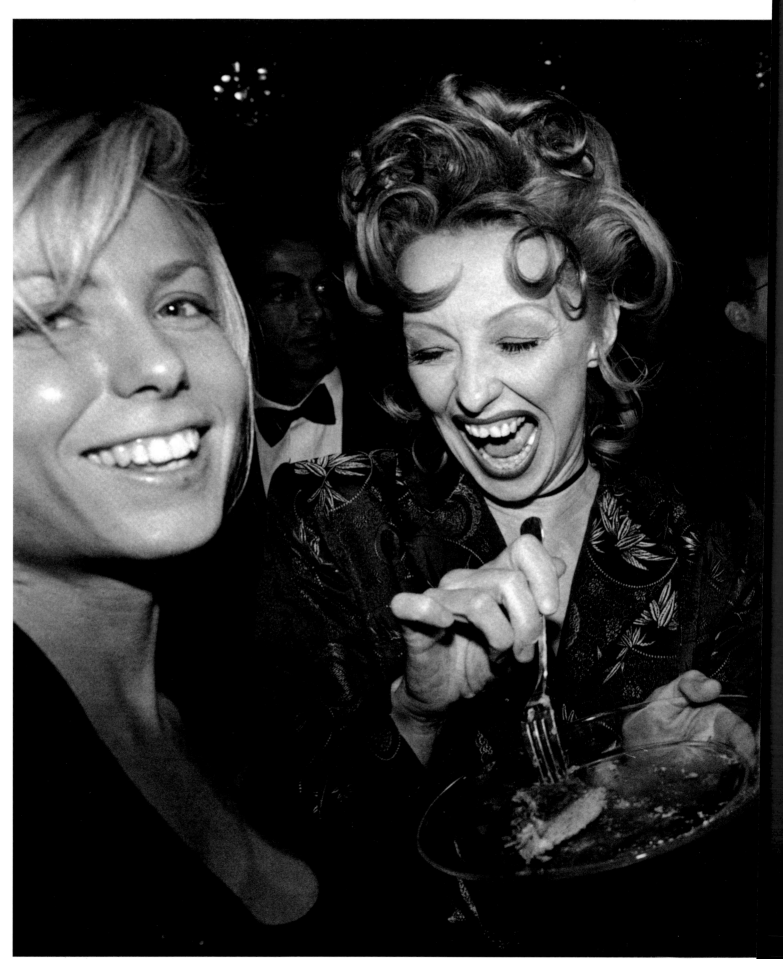

Jeff Mermelstein, *New York City*, 1993

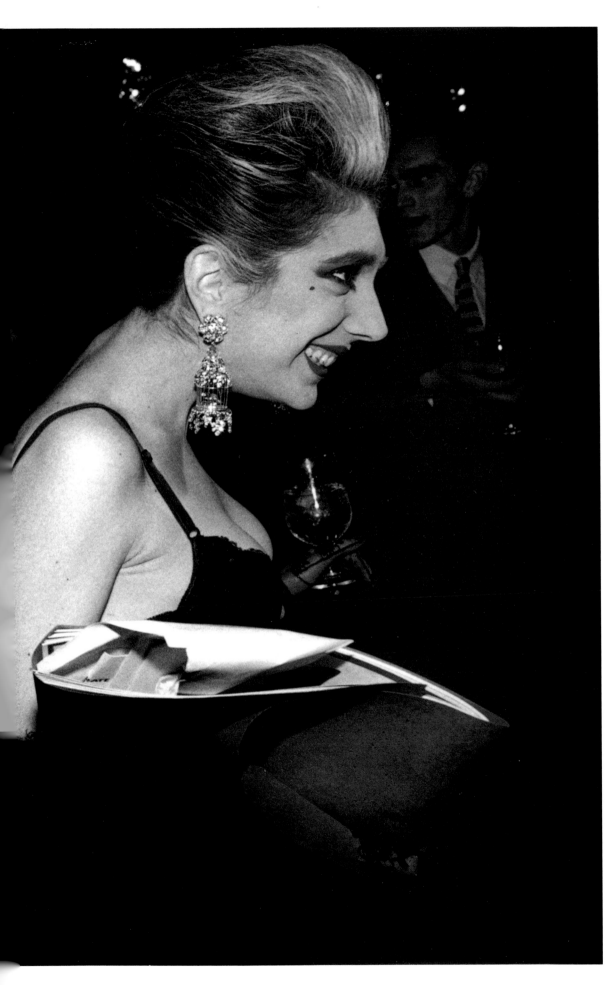

MOST EXTRAORDINARY

OF ALL, I FOUND HER MAJESTY'S

MODE OF EATING.

SHE CHEWED NOTHING.

NOT THAT HER TEETH WERE ANYTHING BUT

FINE AND STRONG;

NOT THAT HER FOOD

did not require mastication. No—

it simply happened to be a habit of

hers never to chew. Meats, previously

tasted by her prægustors, were

chewed for her by her masticators,

who had gullets lined with crimson

satin, with small ridges and golden purling,

and teeth of choice white ivory.

HAVING CHEWED

HER MAJESTY'S FOOD,

THEY POURED IT DOWN

A FUNNEL OF FINE GOLD

INTO HER THROAT.

BY THE SAME TOKEN, WE HEARD THAT

SHE NEVER EVACUATED,

EITHER, EXCEPT BY PROXY.

—Rabelais, from *Gargantua and Pantagruel*

APERTURE: What are your favorite foods?

MARK PEEL: Right now it's early September, we've had a heat wave, and the melons are so sweet. That's my favorite thing right now.

NANCY SILVERTON: I get most excited about the foods I buy at the farmer's market. So they're always seasonal foods. But my favorite food changes daily. One day it's steak, if I have the perfect steak. The next day it's melons, like Mark said, or fresh beans.

MP: You can't make a perfect dish unless each ingredient is perfect. We do a grilled prime rib, with white beans and sauteed bitter greens—it's our most popular thing. Since it's so simple, it's very easy to screw up. The beans are overcooked or undercooked, or someone forgot to salt them. And it's just a pot of beans! But the difference between perfect beans and something halfway to refried beans is night and day.

APERTURE: You like these foods because of how they taste, look, feel, smell?

MP: Texture is very, very important. Food is basically, number one, taste, which combines with smell; number two, texture; and number three, it's visual—in that order of importance. You can't have something that tastes good but doesn't look good and has no texture. Really good sweet corn right off the farm and grilled with butter or herbs is beautiful. I love the charred outside of the corn, the husks as they come off the grill streaked with char bars and colors. Then the texture: when you bite into it, each kernel pops in your mouth.

NS: Ingredients inspire me—even how they naturally fall on the plate. Mark and I sometimes talk about what we call the "pen-and-pencil" cook, where the cook really draws out beforehand the way the dish is to be. It's layered or towered, and that's how it's going to be presented, no matter what the ingredients are. Whereas we may put a slice of duck breast on the plate and then scoop some beans around it, kind of nip-and-tuck them in a certain way, and then kind of fold over some greens. To me that's more beautiful, because the ingredient speaks for itself, and because the presentation is dictated by the way something cooks and looks, rather than the way you thought it should cook or look as you were sitting at your desk.

MP: I want a plate to look Zen—a natural state of bliss, like the way beautiful-colored leaves fall from the tree in fall and drape over the ground. I want it to look as though that's the way it's just supposed to be. A rumpled bedsheet is more natural than a starched military-style sheet.

SILVERTON & PEEL

APERTURE: How do making food and eating it relate?

NS: Very few cooks actually eat the food they make. We have an exposed kitchen, so people in the dining room can see in. And every once in a while they'll complain because they see the cooks taste the food. Now, true, you can do it with a spoon, and you *do* do it with a spoon. But occasionally someone will walk by with their finger out. Now to me, that's so rewarding. I would love to see every cook in the kitchen with their finger in a pot. That means they're tasting it!

MP: Well, that wouldn't make the health inspector happy.

APERTURE: Do you have food rules?

MP: Color is flavor. Don't be afraid to season.

NS: Some people should get in touch with their feminine side when they cook. Mark can make beautiful platters because he's in touch with his feminine side. But is that a food rule—do you tell people, "You've got to get in touch with your feminine side," which is the visual part of the meal?

APERTURE: You obviously think there's a relationship between food and gender. What about food and sex?

NS: One thing people sometimes throw out when they're eating is, "This is better than sex." Then you know you did a good job.

MP: But they're lying.

NS: Okay, they're lying. But either you know they're lying—

MP: Or they have a lousy sex life. Eating is like drinking. If you drink a little, it loosens your inhibitions; if you drink too much, you fall asleep. Making food can be romantic. You have something to do with your hands, an activity, and that loosens

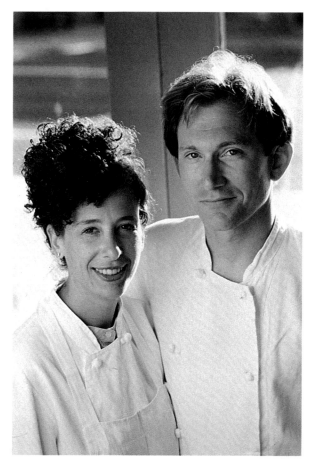

up your talking. A romantic meal can further that. But if you get exhausted by being too ambitious, by making too much, by eating too much, you fall asleep. That's it.

APERTURE: If that's it for food and sex, let's talk about the relationship between food and art. Are we agreed that chefs are artists?

MP: I don't think chefs are artists, any more than carpenters. A carpenter can be a great craftsman, but very few can raise their craft to art. The vast majority of chefs are craftsmen. Great art needs some permanence to it. Calling everyone an artist degrades the great artists' achievement.

NS: I don't think of myself as an artist either. I feel more like a craftsperson.

MP: I get upset because there's no discussion of what art is or is not; or what quality is or is not. You find a degradation of skills. People don't feel they need to learn how to fillet a fish, how to clarify a stock, how to do these tasks—because they're "artists." But if I have no skills, I can't make it art by calling it art.

APERTURE: What's your favorite ingredient, or favorite food?

RICK BAYLESS: If I could answer that I'd probably be a boring cook. It's always changing. We're always trying to understand things about Mexican flavor that we haven't understood before. We regularly travel to Mexico, to taste and eat and enjoy, and to understand the flavors from the viewpoint of the people who have been eating this since they were kids. I'm sometimes just amazed at what's put in front of me. It may have the same ingredients, or maybe an additional ingredient that I've never come across before, but it just opens the world to me. I see the dish in a completely different light.

The food I like most is probably beans. That and corn tortillas, if they're made fresh, are really to me the epitome. If I had to choose anything in the world to live on, basically that's what it would be. If I had some chilis to spice up the duo, I'd be in heaven.

APERTURE: How do you know how something foreign to you should taste when you're cooking?

RB: Only by some sort of instinctual thing. And then I never trust myself completely, so I regularly go to Mexico to taste.

APERTURE: But it's not intellectual. You just know.

RB: My relationship with food is always from the gut. I'm not one of these "head cooks." Everything on our menu I want to fall into the category of something I get a hankering for. That's one of my beefs with haute cuisine—it tends to be more a mind game than a gut game. I never feel like I get a hankering for something I've eaten in a haute cuisine restaurant.

I used to be really into the intellectual concept of food. But Mexican food is from people's hearts, and you don't try to take it apart intellectually. I had to put that away. And when I finally got it put away, I felt like I was on the road to cooking food that people really wanted to eat. Cuisine has to be based on tradition; the best cooking is done by people who respect the roots from which their food comes, and who are doing it as part of their cultural expression. And when I started traveling to Mexico, I saw that that whole sense of regional cuisine was in full force. I had experiences that just burned flavors into my head. My first taste of *molé poblano* was in the state of Puebla, when I was sixteen, in a little converted gas station on the highway. It's a complex sauce, with loads of different ingredients that weave themselves into a singular flavor. And the understanding that there was something so foreign, and so complete, that I could aspire to some day be able to create and enjoy, was an epiphany for me. It wasn't like I understood it; it was just that I understood there was so much more out there.

Commercialized food in the United States has accounted for a dumbing of the American palate. These big companies are always going for the same flavor and texture profile because that's what they think will sell. And because that stuff is pushed at us so much, we've forgotten about the broader range of flavors and the broader range of textures.

APERTURE: In China last summer I saw a McDonald's, and it was packed. Other cultures are assimilating American food.

RB: I don't think what most of the people in that McDonald's were eating had to do with food. I think it had to do with Western culture, or the sense of being progressive, or just showing that they could do it. Cuisine has to be re-created constantly; it has to evolve. People think that if they adopt that food, they'll have a better life-style and all that sort of thing. We're at a strange crossroads, and I hope it doesn't turn out that we wind up with empty-symbol food all around the world—people eating fast foods on an everyday basis and then every once in a while making these other dishes. Because after a while, they'll begin to lose their understanding and the whole culinary ritual.

In Mexican cooking, many of the ingredients are roasted before they're blended into the sauce. But people in Mexico today see that as being of the era they're trying to get away from—the kitchen-out-back era when people cooked over wood or charcoal fires. In the last twenty years, they've moved their kitchens indoors. And the trouble with that is they've stopped roasting everything, so the food has a much less complex flavor.

I learned most of my Mexican cooking from street-stall cooks in rural areas, and those people

RICK BAYLESS

still cook, because they have to, in the old way. And I couldn't believe what flavor you get from this roasting of the ingredients—tomatoes and chilis and garlic and whole onions thrown into the fire and roasted on the outside, so you get this almost smoky, steamed interior that gives a beautiful flavor.

APERTURE: What's the impact you'd like to have? Are you an interpreter? A documentarist?

RB: I want to further understanding of Mexico through its cuisine. From that standpoint I really am working as an interpreter. I'm certainly not the creator of this food.

APERTURE: Are you an artist?

RB: There's not much of a way to describe with our lexicon the way I feel about the artistic element in the role of a chef. I really see us more as craftspeople. But that doesn't explain one element that I think is critical in food, which is that you can create an emotional response through the flavor of your dish, in the same way that good art can create an emotional response. That does make us seem like more than craftspeople in a lot of ways. So I see myself as sort of between that artist-craftperson—

APERTURE: Like the Mexican muralists?

RB: Yeah! Very much in that category.

Above: Garry Winogrand, *New York*, 1963. *Opposite*: Sylvia Plachy, *Tsitsa and Mouse*, 1985

THE LIFE OF PLANTS

IS ONE CONTINUOUS SOLITARY MEAL,

AND RUMINANTS

HARDLY INTERRUPT THEIRS TO SLEEP OR TO MATE, BUT MOST

PREDATORS FEEL

RAVENOUS MOST OF THE TIME AND COMPETITIVE

ALWAYS, BOLTING SUCH MORSELS AS THEY CAN CONTRIVE

TO SNATCH FROM THE MORE TERRIFIED: PACK-HUNTERS DO

DINE *EN FAMILLE*, IT IS TRUE,

WITH PROTOCOL AND PLACEMENT, BUT NONE OF THEM PLAY HOST

TO A STRANGER WHOM THEY HELP FIRST. ONLY MAN,

SUPEREROGATORY BEAST,

DAME KIND'S THOROUGHBRED LUNATIC, CAN

DO THE HONORS OF A FEAST....

—W. H. AUDEN, FROM "TONIGHT AT SEVEN-THIRTY (FOR M. F. K. FISHER)"

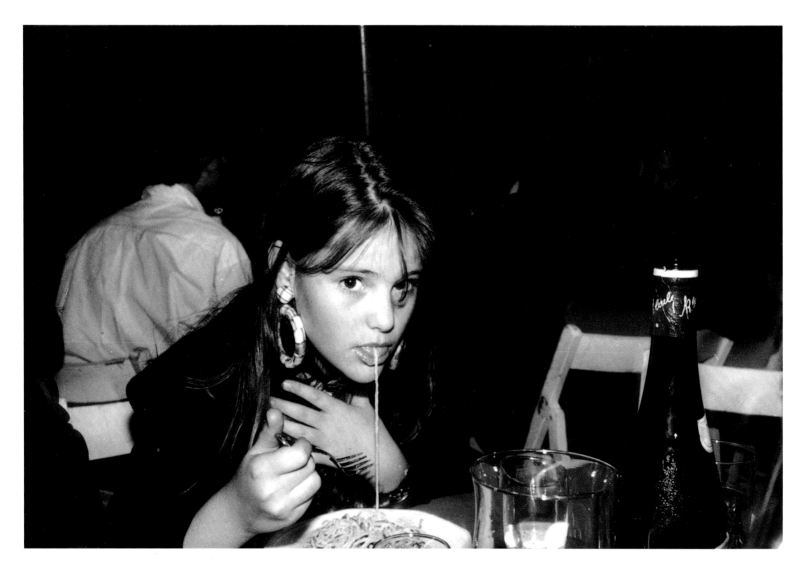

WHILE RECOGNIZING THAT BADLY OR CRUDELY NOURISHED MEN HAVE ACHIEVED GREAT THINGS IN THE PAST, WE AFFIRM THIS TRUTH: MEN THINK DREAM AND ACT ACCORDING TO WHAT THEY EAT AND DRINK.... ABOVE ALL WE BELIEVE NECESSARY: A. THE ABOLITION OF PASTASCIUTTA, AN ABSURD ITALIAN GASTRONOMIC RELIGION. IT MAY BE THAT A DIET OF COD, ROAST BEEF AND STEAMED PUDDING IS BENEFICIAL TO THE ENGLISH, COLD CUTS AND CHEESE TO THE DUTCH AND SAUERKRAUT, SMOKED [SALT] PORK AND SAUSAGE TO THE GERMANS, BUT PASTA IS NOT BENEFICIAL TO THE ITALIANS. FOR EXAMPLE IT IS COMPLETELY HOSTILE TO THE VIVACIOUS SPIRIT AND PASSIONATE, GENEROUS, INTUITIVE SOUL OF THE NEAPOLITANS. IF THESE PEOPLE HAVE BEEN HEROIC FIGHTERS, INSPIRED ARTISTS, AWE-INSPIRING ORATORS, SHREWD LAWYERS, TENACIOUS FARMERS IT WAS IN SPITE OF THEIR VOLUMINOUS DAILY PLATE OF PASTA. WHEN THEY EAT IT THEY DEVELOP THAT TYPICAL IRONIC AND SENTIMENTAL SCEPTICISM WHICH CAN OFTEN CUT SHORT THEIR ENTHUSIASM.

—FILIPPO TOMMASO MARINETTI, FROM *THE FUTURIST COOKBOOK*

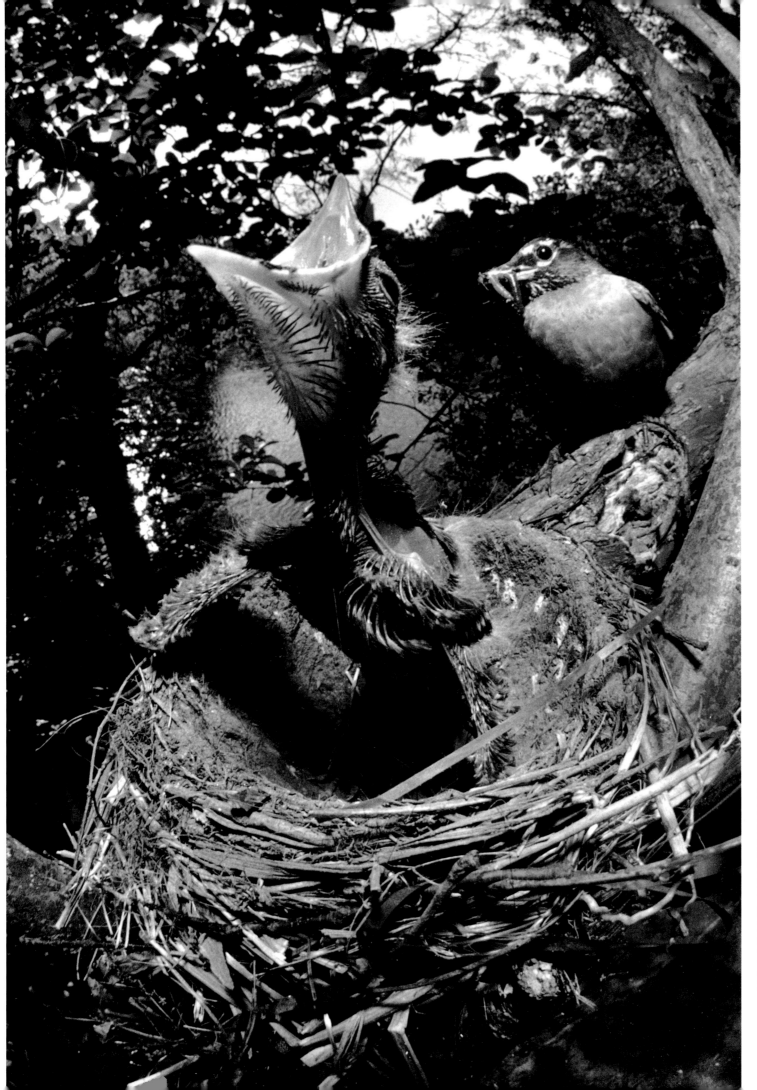

Bruce
Davidson,
*Newborn
Robin in Nest,*
New York,
1994,
from the series
"Central
Park,"
1991–1995.
Opposite:
Jean Pigozzi,
*A Wedding in
Paris*, 1987

WHAT ARE SOME OF YOUR EARLIEST MEMORIES OF FOOD?

DANIEL BOULUD Oh, I was born on a farm, so we had always a lot of food on the table. Breakfast was sausage and eggs, a big breakfast and lunch. Dinner was soup mostly. My mother and my grandmother did the cooking, and we raised our own birds—chicken, turkey, goose, even squab. In the winter, I remember—this is a bit cruel—we'd go and kill the little birds that would nest in the haystacks. It was a way of living. You were living mostly on what you were growing. We raised three pigs a year, and during the winter we would have the pigs slaughtered. I remember hearing them screaming, and it was like the scream from hell! Then for the whole day they would make blood sausage, twenty or twenty-five feet of it. The smell was wonderful. It sounds maybe a little barbaric, but each plate went to a family in the neighborhood. Then when the other farm was slaughtering their pig, they would send us a plate, and we would compare. It was a wonderful thing, you know. And it's something that will never happen again.

NOBU MATSUHISA Since I was a kid, I'm eating Japanese meals. My mom always made food for me. My mom is, I think, the best chef in the world! The Japanese breakfast is very simple—steamed rice, miso soup, a pickle. And for dinner—tempura. Sometimes she bought a whole fish, cut it herself, and made sashimi and homemade sushi. Not fancy, not like restaurant sushi. But it's mom. Your memory goes to your mom. Sometimes my mom made miso soup; I still can't forget the flavors. I tell my chef, "For professional people, cooking is a lot of technique. But my food always has to be with heart." The heart can't see, but it can feel. My mom always cooked with heart. And when she cooked for us, she was always thinking about health, and if you were tired sometimes, then she'd make more powerful food.

BOBBY FLAY Well, mom cooked the basics. Pork chops in apple sauce, lamb in mint jelly. . . .

Things like that totally came into my cooking. I give her a lot of credit for that. Then my mom and dad broke up when I was six, so my father was living on his own. And after a few years he was cooking gourmet meals all the time. Then he started living with this woman who also cooked all the time. He understands food well.

APERTURE So when you were a kid, you didn't have the idea that cooking was what women did?

BF No. And my mother used to tell me, when I was very young, that men are better cooks than women. She'd say, "Well, all the chefs are men." Which was true in 1968.

SYLVIA WEINSTOCK My mother couldn't bake. My mother couldn't cook! So this was a desire for me, to create the home that my mother didn't. I came to baking as a knitter, a sewer, a handcraft person, a hostess who liked to entertain. It was a natural extension for me.

ISMAIL MERCHANT Cooking at home was not something men did in India. It was always women who controlled the kitchen. So it was my mother and sisters, and I went and enjoyed like a pasha, you know. There was never any question of me poking into the kitchen. But I would go on a shopping spree with my father in the morning, to the bazaar, where I saw vegetables and poultry and meat and fish, fruits and salads, all kinds of things that we bought. And that was really one of the interesting things when I was growing up.

APERTURE Did your mother make the shopping list, or did your father buy what he wanted and then your mother had to cook it?

IM No, no, she made the list. She knew what she wanted, you know, and it was always bought. Sometimes things were delivered, like *ghee*, the clarified butter, which would come in this huge carton that lasted for six months. And spices, like red chilis and turmeric and coriander, which were also to last for months. But then my father bought the fresh things for the daily use.

NANCY SILVERTON I hated my mother's lunches. I was horrified by them. She would never buy Ding-Dongs or Twinkies. She also used to make spanakopita and eggplant parmesan from ethnic cookbooks—and my favorite restaurant in the world was Denny's. I used to say, "When I grow up, my kids are going to eat whatever they want to eat, and my refrigerator is going to be full of everything they would want." And you know what? It just didn't happen.

JULIA CHILD I was always hungry, so I ate almost anything that came along.

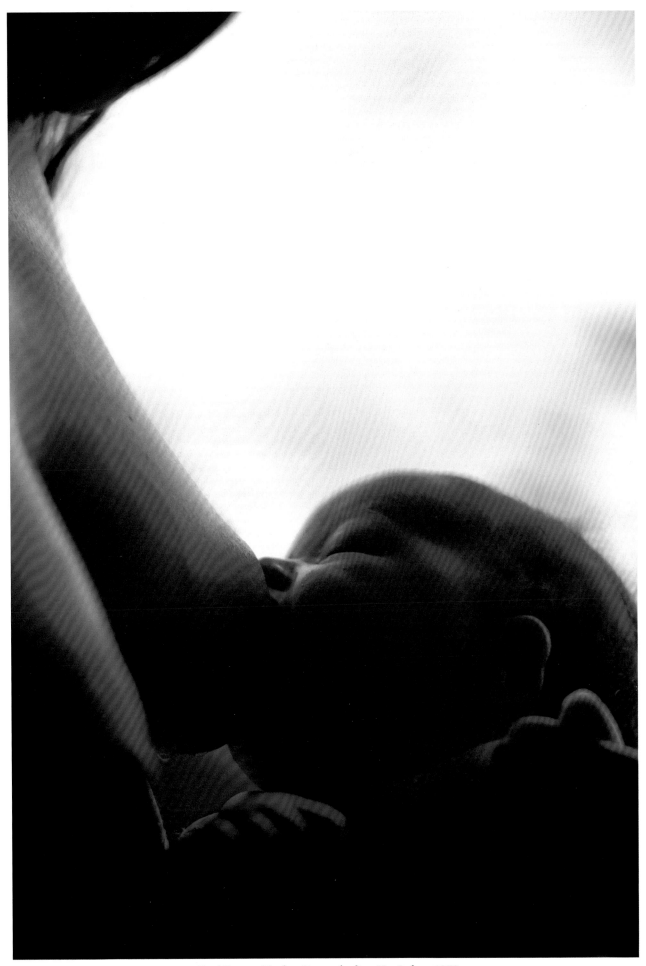

Paul Fusco, *Mother Breast-feeding Her Infant*, 1970

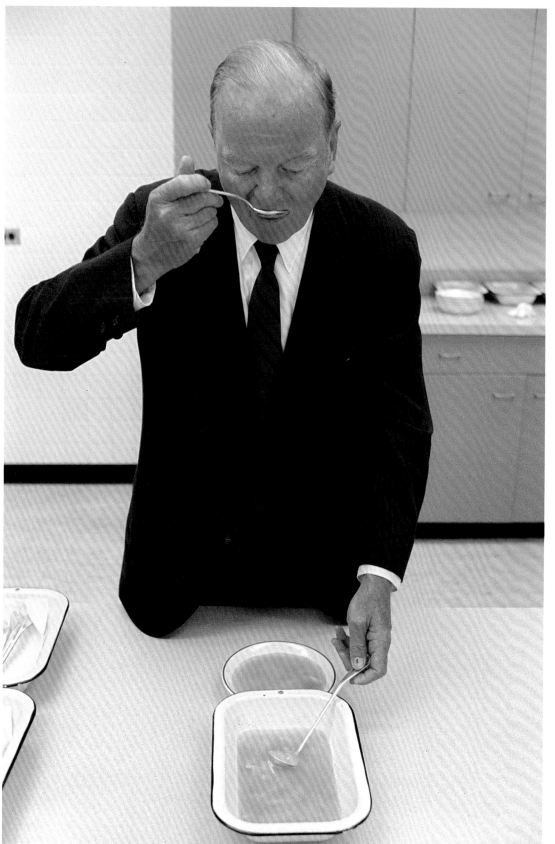

Philip Jones Griffiths, Campbell Soup President W. B. Murphy tastes his product to reassure
the American people after a botulism scare, 1971

PERSONALLY, I LIKE
TASTES THAT KNOW
THEIR OWN MINDS.
THE REASON THAT PEOPLE
WHO DETEST FISH OFTEN
TOLERATE SOLE IS THAT
SOLE DOESN'T TASTE
VERY MUCH LIKE FISH...
PEOPLE WITH THE SAME
APATHY TOWARD DECIDED
FLAVOR RELISH "SOUTH AFRICAN
LOBSTER" TAILS
—FROZEN AS LONG AS THE
SIBERIAN MAMMOTH—BECAUSE
THEY DON'T TASTE LOBSTERY....
THEY PREFER PROCESSED
CHEESE BECAUSE IT ISN'T
CHEESY, AND
SYNTHETIC
VANILLA EXTRACT BECAUSE
IT ISN'T VANILLARY. THEY
HAVE MADE A TRIUMPH OF
THE DELICIOUS APPLE
BECAUSE IT DOESN'T
TASTE LIKE AN APPLE,
AND OF THE GOLDEN
DELICIOUS
BECAUSE IT DOESN'T
TASTE LIKE ANYTHING.
—A.J. LIEBLING, FROM *BETWEEN MEALS*
AN APPETITE FOR PARIS

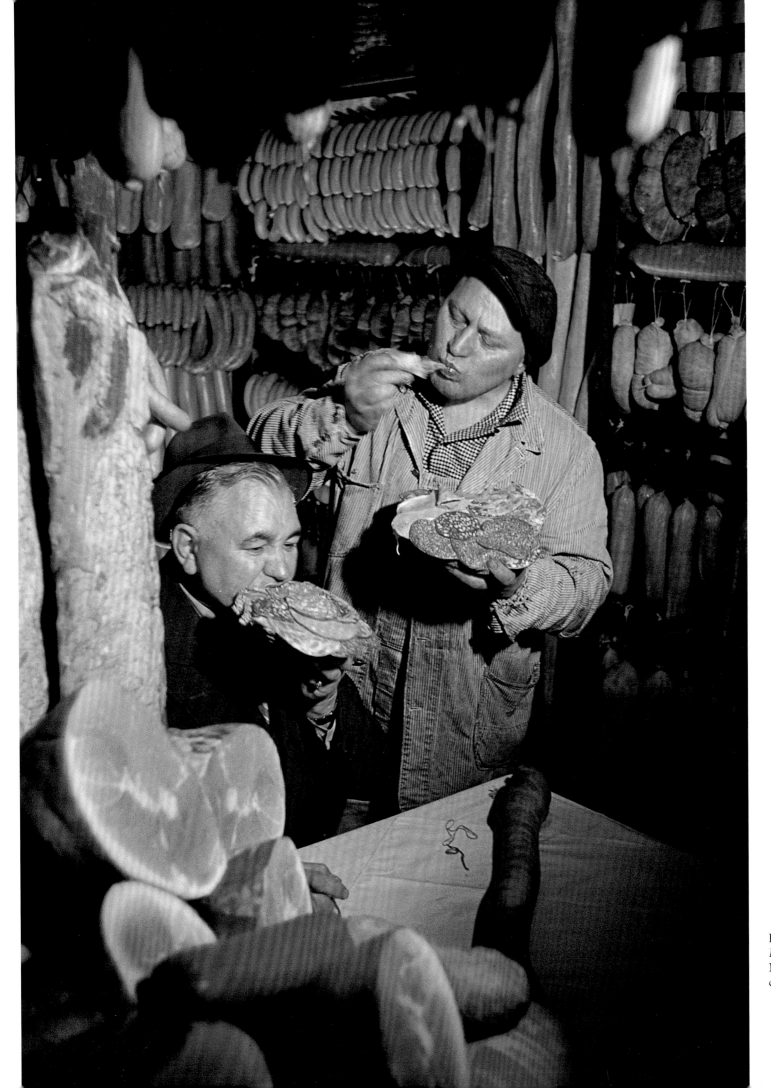

Elliot Erwitt,
Delicatessen,
New York,
ca. 1958

Barbara Kruger,
Untitled, 1995

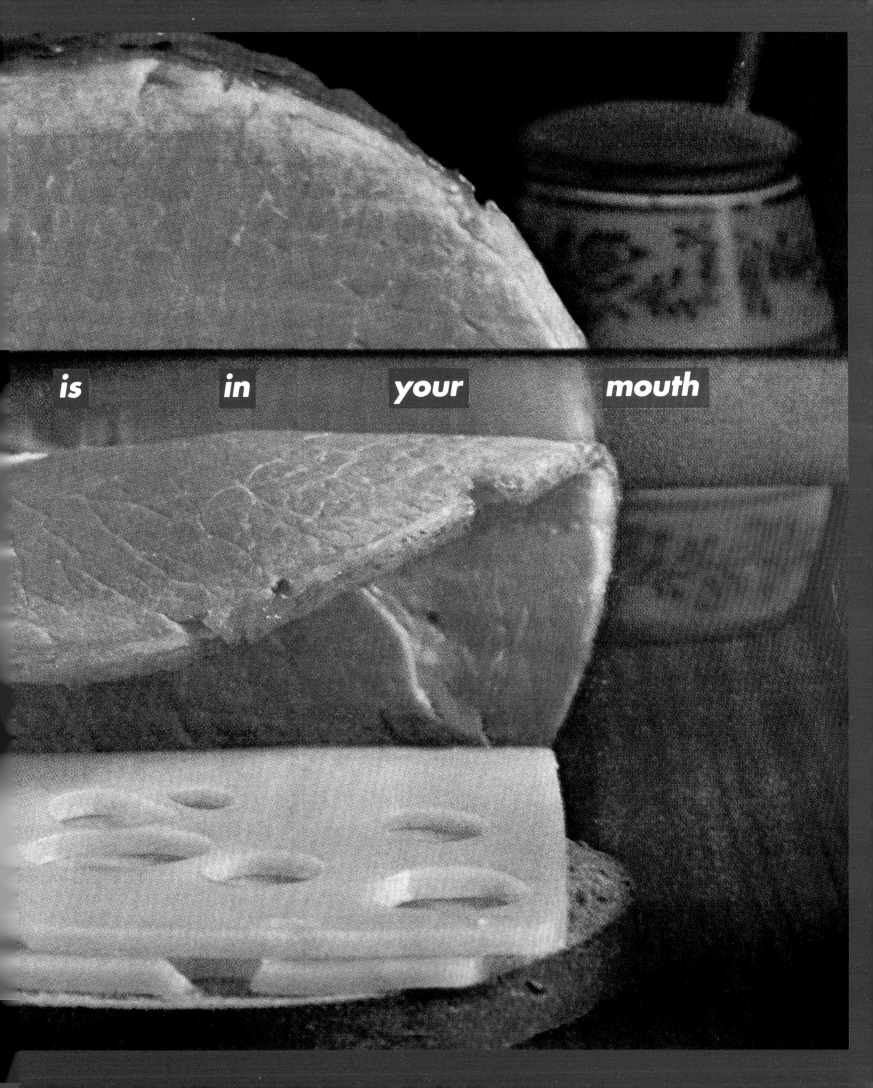

WHAT WAS THE MOST DELICIOUS THING YOU EVER ATE, OR THE MOST DELICIOUS YOU EVER COOKED?

SYLVIA WEINSTOCK One of our most delicious cakes is probably that wonderful French cake that's layered with a hazelnut meringue, mocha buttercreams, chocolate mousses, etcetera. That's just a great thing to eat. I personally like a lemon cake with lemon mousse and fresh raspberries, especially in the summertime. I think it's great. In terms of the look of the cake, it's very hard for me to tell you which is our most beautiful, because we won't let anything out that isn't beautiful.

JEREMIAH TOWER The most delicious thing I ever ate was a puff-pastry tart filled with woodcock and *foie gras* and black truffles, and with a sauce around it made from the bones of the woodcock and a veal reduction. And the sauce was amber brown, actually sort of like topaz, and it was clear as a jewel. If there'd been writing on the plate, you could have read it through the sauce. There wasn't a hint of fat in the sauce—probably because there was so much fat in the tart! The most delicious thing I ever made was probably a soufflé with a very simple shellfish-essence butter sauce.

COPELAND MARKS One of the most delicious things I've ever eaten or cooked is called *fesenjan*. It's an absolutely world-class dish. It's Persian and it's Jewish, but everybody in Persia eats it. Just briefly: it's pomegranate juice, chicken or lamb (chicken is better), and an awful lot of finely ground walnuts. Marvelous.

ISMAIL MERCHANT The most delicious thing I ever ate was my mother's lentils with lamb. I make it myself, but not as good.

DANIEL BOULUD I have to make a picture of where it was. It was the summer. I went home to my parents' home, to Lyons, and I bought a huge sea bass, a real good sea bass—it cost me a fortune. We cooked it in the brick oven, a lot of vegetables around it, olive oil, very simple but, you know, lemon, herbs, a wedge of vegetables, tomatoes, fennel. And it was very wonderful. All right, maybe because the friends around me were also wonderful, and the food was wonderful, and the ambience. There was a wonderful thing altogether.
APERTURE So it tasted delicious because you were home?
DB Because I was home. Maybe because I was very relaxed, and because I was cooking very freely; whatever we were going to find, we were going to cook it. But we had wonderful ingredients, coming from the garden of my parents, and this bass, and the oven. Everything was very natural.

APERTURE Why are your sticky buns so fabulous?
ROSE LEVY BERANBAUM Because the dough is a brioche dough, and it's high in eggs and it's high in butter, and it's yeasty, and it has caramelized sugar on top, and the raisins are plumped up with rum. It's kind of the best of everything you could get. It's not just a bread dough; it's the *richest* bread dough. My theory about sticky buns is that you should just have one, and it should be so rich you don't want a second one. I don't usually believe in overrichness, but in a sticky bun I think it's one of the ultimate American things.

Opposite: William Wegman, *Hot Fudge*, 1994

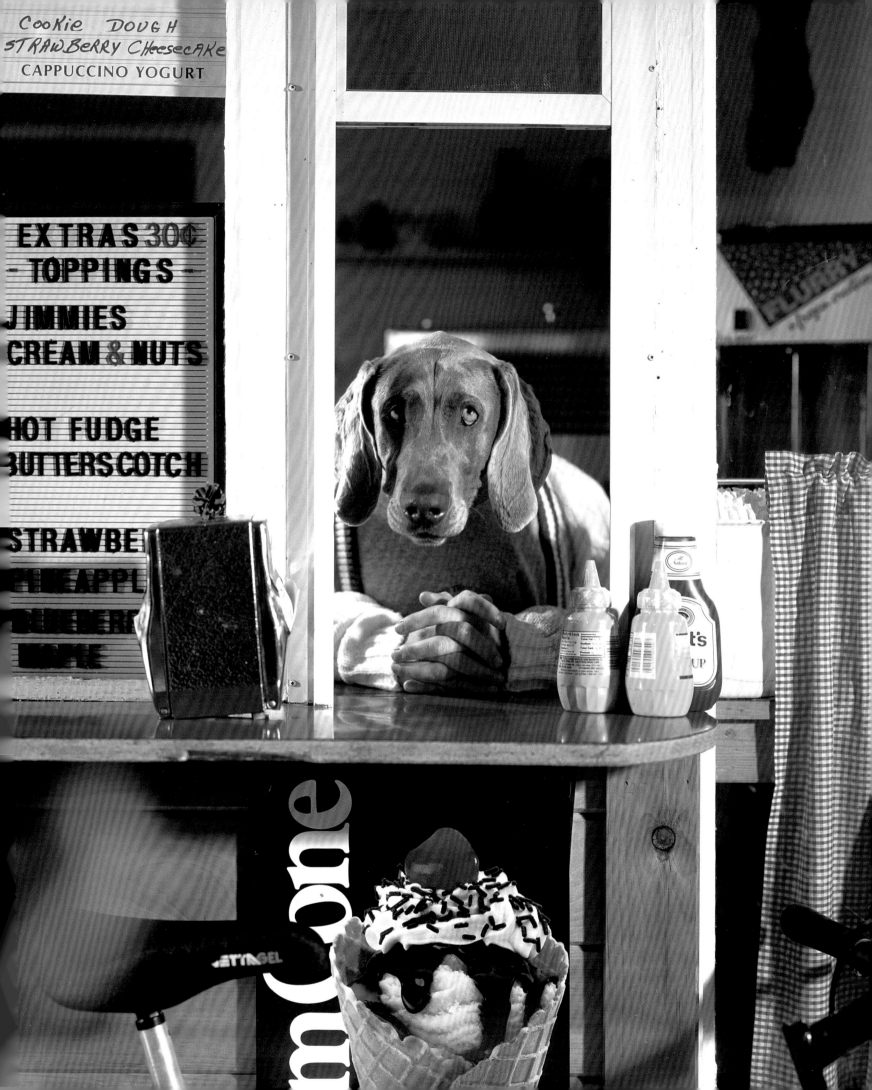

CREDITS

Photographs: Unless otherwise noted, all photographs are courtesy of, and copyright by, the artists: front cover courtesy Houk Friedman Gallery, New York; pp. 3-6 all courtesy Robert Miller Gallery, New York, copyright © 1985 The Estate of Robert Mapplethorpe; p. 9 courtesy Photo Gallery International, Tokyo; p. 10-11 both courtesy Staley-Wise Gallery, New York; pp. 12-15 all courtesy Robert Miller Gallery, New York, copyright © The Andy Warhol Foundation for the Visual Arts, Inc.; pp. 18-19 both courtesy Metro Pictures, New York; p. 20 both courtesy Matthew Marks Gallery, New York; pp. 21-22 (top) courtesy A+C Anthology, New York; p. 22 (bottom) courtesy Magnum Photos, Inc., New York; p. 23 Victor and Marcella Hazan, Rialto Market, Venice, 1995. Photograph by Bruce Davidson, courtesy Magnum Photos, Inc. New York; p. 25 unique image, chromogenic photo by Robert Flynt; p. 26 Bobby Flay in the kitchen of Mesa Grill, 1995. Photograph by Nick Waplington; p. 27 Nobu Matsuhisa in the kitchen of Nobu Restaurant, 1995. Photograph by Nick Waplington; p. 28 courtesy Throckmorton Fine Art, Inc., New York and Magnum Photos, Inc., New York; pp. 30-31 both courtesy of LuhringAugustine Gallery, New York; p. 36 Rose Levy Beranbaum in her kitchen piping meringue, 1995. Photograph by Sylvia Plachy; p. 37 courtesy Metro Pictures, New York; pp. 38-39 all courtesy Janet Borden, Inc., New York and Magnum Photos, Inc., New York; p. 40 (right) Sylvia Weinstock perfecting her cake, Baton Rouge, 1995. Photograph by Travis Spradling. Photographs of Sylvia Weinstock's cakes by Ben Weinstock; p. 41 courtesy Janet Borden, Inc., New York; p. 43 "Plant Power," permanent exhibition at the British Natural History Museum, London; pp. 44-45 all courtesy of JHB Gallery, New York; pp. 46-47 courtesy Janet Borden, Inc., New York; pp. 48-49 both courtesy P.P.O.W., Inc., New York; pp. 50-51 courtesy Paula Cooper Gallery, New York; p. 52 courtesy PaceWildensteinMacGill, New York, and Fraenkel Gallery, San Francisco; p. 53 courtesy Lunn, Ltd.; p. 54 Julia Child melting caramel in her kitchen, ca. 1990. Photograph by James Scherer; p. 55 Copeland Marks in his apartment, seated by a Malaysian ceremonial bowl that contains red-hot, dry chili peppers, 1995. Photograph by Sylvia Plachy; p. 56 courtesy Laurence Miller Gallery, New York; p. 57 both courtesy Robert Miller Gallery, New York; p. 58 Jeremiah Tower in the kitchen of Stars Restaurant, San Francisco, 1986. Photograph by Fred Lyon; p. 59 Daniel Boulud in the kitchen of Restaurant Daniel, New York, 1993. Photograph by Kent Hanson; pp. 60-61 both courtesy Houk Friedman Gallery, New York; p. 62 Ismail Merchant in his kitchen, New York, 1993. Photograph by Derrick Santini; p. 63 Wolfgang Puck in the kitchen of Spago, Los Angeles, 1995. Photograph by Steven Harvey; p. 66 Nancy Silverton and Mark Peel at Campanile Restaurant, Los Angeles, 1994; p. 67 Rick Bayless in the kitchen of Topolobampo, Chicago, 1995. Photographs by Eric Futran; p. 68 courtesy Fraenkel Gallery, San Francisco, copyright © The Estate of Garry Winogrand; pp. 71-75 all courtesy Magnum Photos, Inc., New York; pp. 76-77 courtesy Mary Boone Gallery, New York; p. 79 courtesy PaceWildensteinMacGill, New York.

TEXTS

p. 5 "Single Fish," by Gertrude Stein, from *Tender Buttons*, in *Selected Writings of Gertrude Stein*, New York: Random House, 1946, page 489; pp.10-11 excerpt from the Introduction to *Naked Lunch*, by William Burroughs; p. 28 excerpt from "Mushroom Book," by John Cage, in *M: Writings '67-'72*, copyright © 1973 John Cage, Middletown, Connecticut: Wesleyan University Press, page 119, reprinted by permission of University Press of New England; p. 31 excerpt from "On Murdering Eels and Laundering Swine," by Betty Fussell, from *Antaeus*, Spring, 1992, reprinted by permission of the author; p. 42 excerpt from "The Emperor of Ice-Cream," by Wallace Stevens, from *The Collected Poems of Wallace Stevens*, New York: Vintage Books, 1990, page 78; pp. 44-45 excerpt from "Eating Women is Not Recommended," by Éilís Ní Dhuibne, from the anthology *Eating Women is Not Recommended*, Dublin: Attic Press, 1991, pages 135-136; p. 52 excerpt from *The Temple of the Golden Pavilion*, by Yukio Mishima, translated by Ivan Morris, New York: Alfred A. Knopf, Inc., 1994, page 58; p. 65 excerpt from *Gargantua and Pantagruel*, by François Rabelais, from *The Five Books of* Gargantua and Pantagruel *in the Modern Translation of Jacques Le Clercq*, New York: Random House, Inc., page 752, reprinted by permission of The Limited Editions Club; p. 69 excerpt from "Tonight at Seven-Thirty (For M. F. K. Fisher)" by W. H. Auden, from *Selected Poems*, New York: Vintage Books, 1986, page 271; p. 70 excerpt from "Against Pasta," by Filippo Tommaso Marinetti, from *The Futurist Cookbook*, San Francisco: Chronicle Books, 1989, pages 36-37, copyright © 1989 the Estate of F. T. Marinetti, English translation copyright © 1989 Suzanne Brill; p. 74 excerpt from *Between Meals: Liebling in Paris*, by A. J. Liebling, San Francisco: North Point Press, 1986, page 62, copyright © 1959, 1962 A. J. Liebling, copyright ©1981, 1986 the Estate of A. J. Liebling, copyright renewed in 1987 and 1990 by Norma Liebling Stonehill, reprinted by the permission of Russell & Volkening as agents for the author.